Designs for 20th-century Interiors

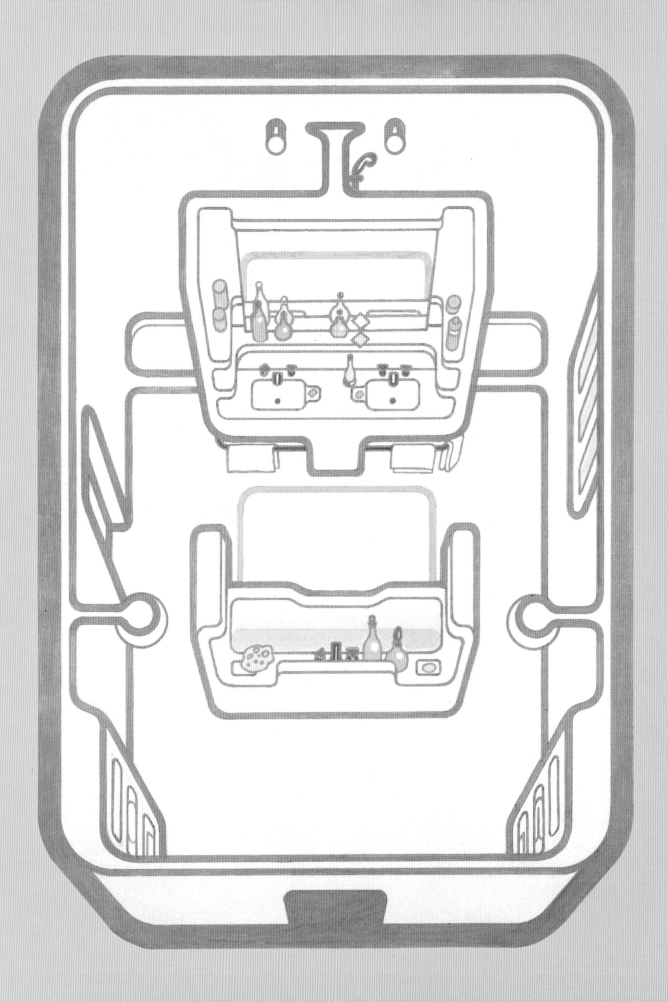

Designs for 20th-century Interiors

Fiona Leslie

V&A Publications

To my Mother and Father

Front jacket: 'Bauhaus' furnishing fabric,
1969–70. Designed by Susan Collier and
Sarah Campbell. (See plate 20.)
Inset: Tubular chairs in domestic setting, 1977.
Drawn by G. P. Ward for Conran Associates.
(See plate 22.)

Back jacket: 'Long' chair, 1936. Designed by
Marcel Breuer. (See plate 12.)

Frontispiece: Design for a bathroom for the
'Take A Room' series in the *Daily Telegraph
Magazine*, 1968. Designed by Max Clendinning
and drawn by Ralph Adron. (See plate 64.)

First published by V&A Publications, 2000

V&A Publications
160 Brompton Road
London SW3 1HW

ISBN 1851773215

A catalogue record for this book is available from the British Library.

Designed by Yvonne Dedman
New photography by Graham Brandon, V&A Photographic Studio

Printed in Hong Kong by South Sea International Press

Contents

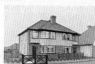

Fig.1. Leaflet advertising the Coronation
'Arcadia' semi-detached master home, 1930s.
Designed by Jackson Burton (worked second
quarter of the 20th century).
V&A: E.567–1987

And now we of the Twentieth Century can only add material comforts and an impression of our personality. We raise the house … we give it measured heat … water in abundance and perfect sanitation and light everywhere … ventilation … and finally we give it the human quality that is so modern.

Elsie de Wolfe, *The House in Good Taste* (1914)

Introduction

The inside of the typical British middle-class home in the first decade of the 20th century looked very different from its equivalent domestic residence of 1999. Changing lifestyles, industrial developments, technological innovations, architectural trends and shifts in taste influenced the way that domestic activities were arranged, together with the decoration and furnishing of the spaces in which they took place. Looking at designs for fashionable decoration and the plan of rooms, this book aims to show how and why the appearance of domestic interiors has changed throughout the last one hundred years.

The nature of good design was much debated throughout the century, by both official and unofficial design pundits. Rather than delve into this debate,

this book explores styles that were popular and influential over the years. In practice, the forces of popular culture and mass consumerism had at least as much impact on high design as the other way round. As a result, design both reflected and informed the culture of the society it served.

The consumer age of design

Part of the challenge of presenting British design of this period is to give a sense of the multitudinous nature of the styles that were taken up and used in people's homes. Whilst design styles of the 19th century could be generally described as both traditional and eclectic, and were used by a relatively small part of the population, in the 20th century they were much more complex, reflecting the changing nature of consumers. Most importantly, design was participated in and enjoyed by a very much larger section of society. As a result of industrialisation and mass production at the end of the 19th and beginning of the 20th centuries, the middle class had grown in affluence and swelled in numbers. The 20th century saw the growth of mass markets and popular culture, where a larger proportion of the population than ever before had the money and time to spend on choosing and purchasing products for the home. Consumer demand required the market to change at an increasing pace, supplying annual and seasonal innovations and trends to satisfy its appetite for the new and exciting. This so-called 'democratisation' of design resulted in the fast turnover of styles. The increased accessibility of styles, however, forced the design 'snob' into ever extreme territory. The bid to retain exclusivity resulted in a bracket of design which involved expensive materials and unusual and obscure gimmicks. The 1990's cult of the designer (which came out of the 1980's fashion for designer labels in clothes) played to both sides of the market. While top designers were put onto pedestals, many also began to work for popular retailers, such as Habitat, enabling a wider market to participate in the lifestyles they were creating. One of the marked shifts in design in Britain was the move from design as an agent in changing society (in the late 1940s), to design as a forum for marketing and lifestyle (in the late 1980s and 1990s).

The ability to exercise choice has resulted in the continued popularity of some styles. So while design histories often provide a chronological narrative of the succession of styles, it should always be kept in mind that not all new fashions are taken up immediately, or instantly dropped on the arrival of a

new style. Even at the top end of the market, where designers and architects are commissioned to provide a particular look in a home, very few complete schemes remain for long as the designers envisaged them. It is often the case that some favourite piece of furniture or decorative object is introduced into a designed scheme. In reality, most homes of all classes are an eclectic assemblage of furnishings which are there through habit, chance, sentimental value and different aesthetic preferences.

The home

The domestic concept of the home was an important focus for designers and architects throughout the 20th century. In Britain there was a higher percentage of homeowners than in Europe and America, which meant that a greater percentage of the populace had control over decisions about decorating and furnishing their home. The idea of the home was central to much of the work of architects and designers of the Arts and Crafts movement. Their inclusion of homely mottoes above fireplaces, such as, 'East, West, Home Is Best', reflected their social values and their efforts to create comfortable, interesting living spaces. Arts and Crafts ideals and designs were highly influential in domestic interiors until the second decade of the 20th century, and to a lesser extent for the rest of the century. After 1919, there was a substantial rise in wages which was soon followed by a boom in house-building, usually by speculative builders. This brought owner-occupied homes within range of the average skilled workman. For many, it was the first time in their family's history that they had had control over the decoration and furnishing of their home. The purchase of a house and its contents to create a home was seen to be for life. With the rise of mass-produced cheaper goods and the increase in population movement after the 1950s, however, the idea of 'home' and goods being in possession forever became less relevant. The cheaper mass-market could only be maintained by the constant turnover of goods. Clever marketing and advertising ensured that goods were quickly replaced, either through fast-changing fashions (often requiring objects to be designed with in-built obsolescence), by convincing 'punters' that they needed more than they really wanted, or through cheap quality products that 'self-destruct' in a short time. Towards the end of the century there was a move towards better quality and better designed products in both the mass-retail market and in the high-design market. Partly brought about by the influence of Scandinavian retail

design in the early 1990s, both consumer markets enthusiastically bought into this marked improvement.

The character of the decoration and arrangement of domestic living spaces says something about the people who live in them and, as such, the home acts as a social catalyst for self-definition. Although this was not a new concept, it took on a much more materialist emphasis in the 20th century. Even though social formalities in the domestic sphere declined, the sense of showing who you were through your choice of styles and taste in decoration and furnishings continued. Personal tastes, social status, aspirational aims and pocket were revealed, notably through the acquisition of up-to-the-minute domestic products, whether they be technological household products, the latest floor covering or a limited edition high-design chair. Ultimately, finances permitting, one could buy into any lifestyle through the choice of design look.

Rooms as architectural spaces

It is not possible to look at rooms without putting them into their architectural context. The room relates in form, function and meaning to the architecture of the building that houses it. One thousand years ago, most functions were carried out in one space. Since then different social functions and developing etiquette have required partitions and divisions to be created within the living space. By the end of the 19th century this had resulted in, at the basic level of living, two rooms in a home, one for living, cooking and eating and the other for sleeping. At the other end of the scale, a large home (with servants) might have had over fifty rooms for at least thirty different social needs and service functions. From the first decade of the 20th century, the clearly designated functions of rooms began to change. The organisation and decoration of the new living spaces reflected changing lifestyles right through the century. Ceiling heights dropped, floor plans shrank and then swelled as walls were removed, rooms were amalgamated and areas were opened up to create multi-functional living spaces. The middle-class home witnessed the introduction of bathrooms and the loss of drawing rooms, the growth of kitchens and then kitchens that grew to include diners. From the 1930s sitting rooms stretched around to embrace dining rooms, and for a time walls almost disappeared entirely in favour of the open-plan – later epitomised in the loft-conversion. Bedrooms, however, have remained much the same in size, function and furnishing.

One of the main shapers in British middle-class homes has been the increasing pressure on living space, particularly in urban dwellings. This, together with the decline in the use of servants in the middle-class home after the First World War, resulted in smaller houses with fewer rooms. For the established middle classes, this necessitated the reorganisation of the functions and activities of family life into smaller spaces. For new arrivals to the middle class it meant an increase in space as they moved to the new three-bedroom semi-detached houses in suburbs around the country. The advertisement for the semi-detached shown in fig.1 (see page 6) enticed rent-paying city dwellers to buy into an improved lifestyle, exclaiming, 'Look what you can afford to possess'. Preferable to terraced housing in the inner-cities, these were symbolic of a whole new living experience for many. They were to become a standard house type in Britain for the next fifty years. Post-war town houses in Britain experienced an opening-up, as walls dividing reception rooms were removed to create through rooms, which had the advantage of being one larger space lit from windows at both the front and back of the house. By the 1960s, halls too had been amalgamated into the growing living space, creating a sense of spaciousness which can be related to earlier house plan developments in America.

At the turn of the century, space for building homes in America was not a problem, and so house layouts could take a different shape. Architects such as Frank Lloyd Wright (1867–1959), working at the top end of the market, took a less inhibited approach than the British, resulting in quite the opposite treatment of the living space, as well as a new attitude to behaviour and living in the home. Wright reinterpreted the room and its walls by dissolving or breaking them down from their rigid, box-like confinement. Greatly influenced by Japanese architecture, this idea resulted in a sequential assembly of living spaces and what became known as 'open-plan' interiors, influencing house design all over the world.

Public spaces and the domestic interior

The increasing affluence of 20th-century Britain meant more leisure time for many people. The growing array of shops and places of entertainment after 1918 exposed a greater number of people to a wider range of architectural and design possibilities, which were often taken into the home. Time spent in the growing leisure activity of shopping for all the newly available domestic

products was a big change in many people's lives. Shop fronts and interiors were designed to entice. The American designer Norman Bel Geddes (1893–1958) wrote in 1935 that the three things a window display needed to do were 'arrest the glance; focus the attention upon merchandise; persuade the onlooker to desire it'. Thus, over the century, many industrial designers have been involved with shop design, as seen in the 1976 design drawing for Levi Strauss (fig.2) by Conran Associates. The use of the Scandinavian style – open, blond-wood floors and light-framed clothes rack systems – allowed the customer to experience the feeling of spaciousness in the shop, and gave ideas for its use in the home. Other stylish social spaces included bars and restaurants. Raymond McGrath's 1932 design for the interior of Fischer's Restaurant (fig.3) shows his liking for long, sweeping staircases with shiny chromium banisters. He also developed this Modern form of staircase in his designs for domestic commissions. The rich, warm colours and forms that were typical of Continental Art Deco can be seen in an early 1930s club bar design (fig.4). Such settings influenced the look of bars introduced at this time into many living rooms in wealthy middle-class apartments, where they were seen as a symbol of high-society.

Another important public space for providing design ideas was the cinema auditorium. During the 1930s cinema was the fastest growing form of entertainment. With the backdrop of world depression, many thousands of people went to watch films to escape the difficult reality of their lives. Many ideas for home decorating were influenced by the glamorous film sets, but it was not just the film-watching that was important. The cinema-goers' experience started as soon as they walked in through the doors. The lobbies, staircases and auditoria of these people's palaces were built and decorated to impress, with fantastic themes and exotic styles created by designers who had not previously had the opportunity to design on such a scale or with such large budgets.

Fig.2. Design drawing of an in-store display system for Levi Strauss, 1976. Pencil and felt-tip pen. By Conran Associates.
V&A: E.5223–1976

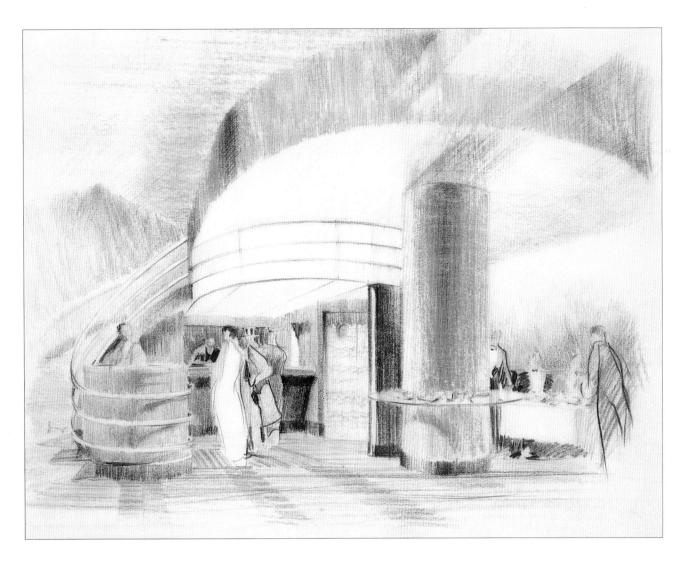

Fig.3 (above). Design for the interior
of Fischer's Restaurant, 1932.
Pencil, crayon, gouache on tracing paper.
By Raymond McGrath (1903–77).
V&A: Circ.565–1974

Fig.4 (below). Design for a bar in a
Viennese club, early 1930s. Pencil, pen
and ink, watercolour and gouache on
tracing paper. Probably designed by
Eduard Josef Wimmer (1882–1961).
V&A: Circ.397–1977

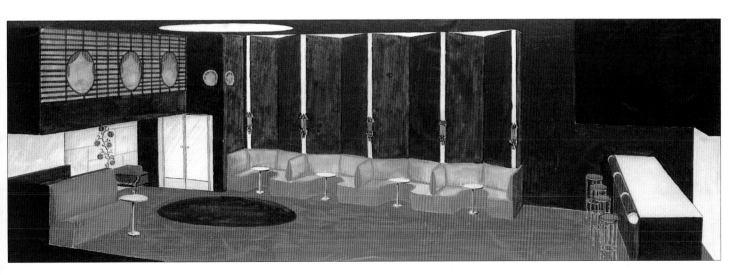

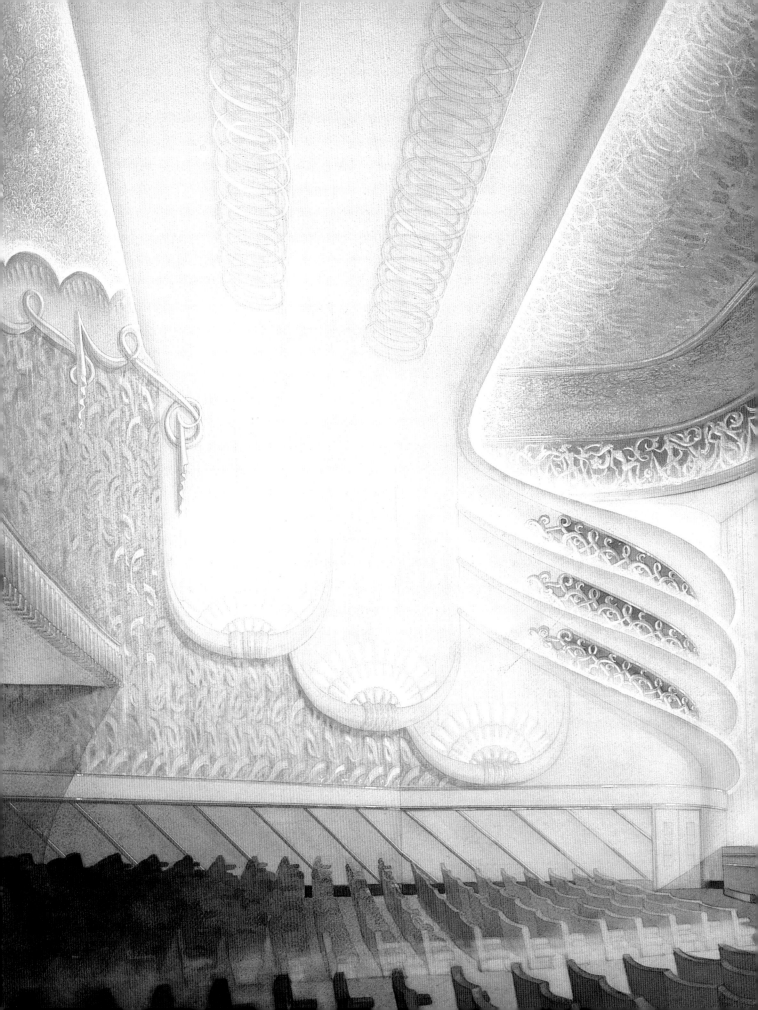

The auditorium in fig.5 is typical of the exuberant and expensive design that characterised cinemas at this time. In 1937 alone, 229 cinemas were built, seating 303,000 people and bringing the total number of movie houses in Britain by the end of the 1930s to over 4,700.

For many people during the century, the office became a principal living space. It should be noted that from the 1970s there was a marked increase in working from the home; this resulted in living rooms accommodating study or office areas, or even whole rooms dedicated to work. Due to a lack of alternatives they are often furnished with furniture made for the office environment, although in recent years designers have been addressing the market for less workaday furniture and products for the home-office environment.

Styles in domestic interiors, 1900–1999

In the opening quote to this chapter, the influential decorator Elsie de Wolfe (1865–1950) very succinctly raised some of the issues which were key to designing the 20th-century living space. From the last quarter of the 19th century, social and religious campaigners had successfully helped to raise standards of hygiene in housing, particularly in urban environments. By the early 1900s the improved conditions had resulted in an emphasis on light, fresh air, clean water and efficient sanitation in the home. These basic amenities were accepted practice in most newly built middle-class housing by about 1910. At first this trend mainly affected the furnishing of bathrooms and kitchens, but it then spread into other living areas of the home; for example, windows became larger and wall colourings lighter. Then it was just a case, as de Wolfe suggests, of decorating to the tastes of the home owner.

The styles used to decorate middle-class homes of the first years of the 20th century took the form of the established Victorian taste for Arts and Crafts and Art Nouveau, which continued up to the outbreak of the First World War in 1914. The first decade saw a house-building boom in cities, and many homes were fitted for the first time with the newly developed electric lighting. This, combined with the taste for 'lightness' referred to by de Wolfe, resulted in Edwardian domestic interiors becoming lighter and brighter. While there were avant-garde movements such as the Omega Workshops (which opened in 1913), traditionalism, in the form of floral patterns and heavy wooden furniture, was prevalent, often in houses with historical Tudorbethan exteriors. Arts and Crafts and Art Nouveau seemed definitely

Fig.5. Design for a cinema auditorium, from 1935–39. Pencil, watercolour and Chinese white. By John Alexander (b.1888). V&A: E.295–1998

old-fashioned by the end of the war in 1918. The Omega designers were still active after the war, but their Continental-inspired, painterly, abstract-style decoration was too shocking and radical for most middle-class homes. However, they were responsible for rekindling the interest of fine art designers in the applied arts, which carried on throughout the century.

In the 1920s, when thousands of people in Britain, often young professionals, were purchasing new homes for the first time, it was such a major financial undertaking that they couldn't always afford new furniture as well. With the help of friends and relatives, old pieces were mixed in with the new. It was also the case with decorations such as wallpaper, which came ready fitted, that there was little choice given to the new owners and often cheap, old-fashioned and end-of-line wallpaper was put up by the builder.

In Continental Europe, International Modernism was taking shape in organisations such as the Bauhaus Workshops in Germany, which operated from 1919 to 1932. Bauhaus styles and ideas, unifying art and technology, resulted in the stripping away of decoration in favour of plain, straight-lined interiors. The designers did not attempt to disguise the social purpose behind the style, which was aimed at cheap mass housing. In Britain, Modernism was set against a backdrop of traditionalism and was never widely taken up in such a strong and pure form as on the Continent or in America.

In the 1920s and 1930s, America was also home to the Moderne Style, which was a synthesis of Art Deco materials with the minimalist lines of the Modern Movement. The Modernist, functionalist forms were in the main viewed with suspicion by wary British utilitarian and empirical traditionalists, and were seen as being virtually synonymous with political movements such as Communism. Many Britons felt their traditionally eclectic use of style was threatened by the stark, austere appearance of buildings and their interiors. In addition, new materials were viewed sceptically, as seen in fig.6, a humorous design by William Heath Robinson for his book *How to Live in a Flat* (1936). Plain, light-coloured walls, which fitted in with the Modernist sense of minimalist decoration, were widely taken up, but only because of the impression of greater space they gave. Modernists, however, argued that the smooth and sensible functioning gave greater personal freedom and independence. The standardisation of living spaces was intended to free the individual for more important and culturally richer activities. Architects and designers in Britain such as Wells Coates (1895–1958) and Erich Mendelsohn (1887–1953) were

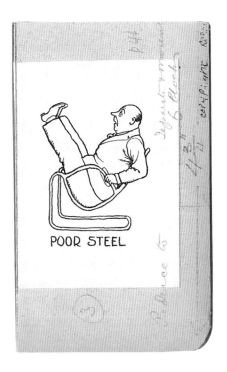

Fig.6. 'Poor Steel', 1936. Pencil, pen and ink. By William Heath Robinson (1872–1944) for his book *How to Live in a Flat* (1936). V&A: E.1655–1989

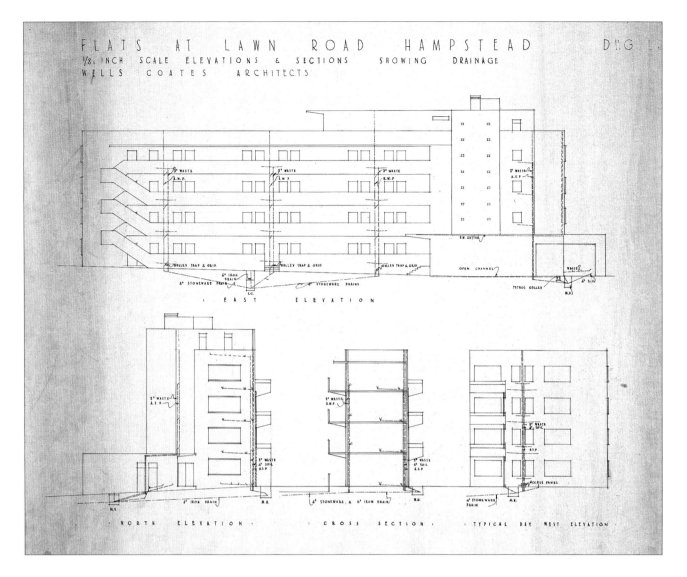

Fig.7. Front elevation of Lawn Road Flats, 1932–33. Pen and ink on linen. By Wells Coates (1895–1958). V&A: E.684–1980

able to practise Modernist architecture. Coates was given the opportunity with the financial support of Jack Pritchard, a major proponent of Modernism in Britain. He built Lawn Road Flats, a residential housing scheme in Hampstead, North London, finished in 1934. Fig.7, showing the front elevation, was drawn between 1932 and 1933. Now the object of a heritage campaign, Lawn Road Flats was then popular with and inhabited by artists, cultural types and European émigrés such as Marcel Breuer, who brought the Modernist forms with them, but was never popular with British homeowners. British planning authorities often stopped Modernist houses being built, but eventually Modernism – in a modified form – did come into public housing in the 1950s and 1960s.

In 1930's America, with its vast home market, designed goods and industrial designers enjoyed a high profile. Consumer products, particularly in the labour-saving market, were becoming more and more sophisticated, with

great attention being given to design details. The machine-age aesthetic of streamlining was particularly prevalent in kitchen goods, which lent themselves to the smooth, metallic, teardrop forms that were being developed. Streamlining was soon found in larger, more obvious products such as cars and trains, as the aerodynamic shapes had a currency with the fast-moving objects which they defined. Styling became all important and the designer with it. But this notion did not find its way to Britain in any major way until the 1950s.

With the outbreak of the Second World War in 1939, nearly all design and manufacture in Britain went towards the war effort. After two years, Britain experienced problems with materials supply, particularly wood from the USA. In 1941 the Government Board of Trade set up the Utility Furniture Scheme as a means of rationing production and consumption of furniture. The board introduced specifications for controlling the dimensions and materials of pieces of furniture for all over the home: from chairs, kitchen cupboards and wardrobes to babies' play-pens. The resulting furniture was straight edged, plain and unembellished, in which form very much followed function and construction. The restrictions went on until 1953, and although Utility furniture furnished many middle- and lower-class homes, it was seen as an austere necessity during the war, and was soon therefore rejected after the restrictions were lifted.

But the design establishment had not forgotten the issues surrounding industrial design developments, particularly with the pre-war glimpse of Uncle Sam's highly styled products. The Utility Scheme had been used as an attempt by members of the Board of Trade Design Committee to raise what they saw as a low level of design in Britain. In 1944 the Government set up the Council of Industrial Design 'to promote by all practical means the improvement of design in the products of British industry'. One of its aims, as stated in the Design Fair exhibition catalogue of 1944, was 'to promote a wide understanding of what makes a good design'. At the end of the war, in 1945, this was uppermost in the Council's mind. In an attempt to re-establish peace production and to boost the home market and confidence in British goods, the Council of Industrial Design organised the Britain Can Make It exhibition of British commodities. Held at the V&A, each company or manufacturer had a stand showing goods from household linen, powered domestic equipment and toilet-table top requisites to garden tools, men's wear and children's wear,

and items for the nursery. Some stands were in the form of complete room sets and all exhibits were passed by a selection panel. Visited by thousands, many thought the goods were too expensive for the average pocket, and as most of the products on display were only available for export, the show was nicknamed 'Britain Can't Have It'. The focus of a mass observation exercise, feedback from visitors made it clear that what the Utility Scheme was offering was not liked or wanted by most members of the public.

American industries weren't affected so badly by the Second World War, and design carried on being driven by the ever-quickening race to capture the increasing consumer markets, led by the cry of the marketing departments. Selling not just goods, but a whole new approach to lifestyle, the American 'imperialistic', product-marketing machine changed the face of British and European design forever. In addition to American-designed goods at this time there was an influx of Scandinavian products and design ideas. The light-weight, slender wooden forms of furniture from Sweden and Denmark made a big impact in Britain during the 1950s. Their use of different types of wood, particularly blond-woods and teak, fed into the traditionalist, almost Arts and Crafts niche for well-designed, good-quality natural materials. The resulting design in Britain had a much more international flavour and sophisticated look about it.

All over Europe, the 1950s saw a break with old orders and the establishment of new ground in design. In 1951, the Festival of Britain, held in London and around the country, was intended to boost British trade. It was a successful launch pad for many designers and architects who, inspired by the new times, showed their new products for Britain and the world to see. These often took the form of bright, colourful fabrics, and new plastics revolutionised the shapes goods could take. Designers were able to satisfy the market which reacted against the plain undecorated furniture of the rationed war years in favour of more ornately patterned and decorated furniture and furnishings. Furniture manufacturers tried to define a more subtle, well-made, modern look for British furniture. Retailers began to promote a composed and co-ordinated look for the room in new suburban homes with three-piece suites of furniture and matching covers and draperies – an important stylistic trend. Houses and homes began to be designed to fit in with new lifestyles. This was the period of the Wimpey 'T.V. house', in which the television could easily be viewed from the sitting and dining areas and where the kitchen wall

opened up so that housewives could watch while they cooked, reflecting the 1950's craze for television.

The challenge of using new materials and techniques to create new lifestyles was taken up by Alison (1928–93) and Peter Smithson (b.1923), whose 1956 'House of the Future' was controversial at the time. The design (fig. 8) was commissioned for the Ideal Home Exhibition, and was a forward-looking ideal for a new interior architecture to accommodate new ways of living. This concept house, comprising of a simple brick box without external windows, was intended for back-to-back mass housing. Internally, the door-less rooms were to be made out of modular prefabricated sections and panels, a technology which had come out of the aeroplane and car manufacturing industries. The moulded, plastic-impregnated plaster 'rooms' were intended to be fitted around a central garden, which was the only source of light. The stark profiles of the Smithsons' buildings had been described by critics as the 'new brutalism'. The 'House of the Future' embodied aspects of this, together with the architects' inspiration from Pop Art, which had grown out of their interest in the American advertising culture of the 1950s. It was referred to by the *Architect's Journal* (March 1, 1956, pp. 236–37), two weeks before it opened, as the 'house of 1980'. The house also contained ideas of labour- and space-saving devices such as a self-rinsing, thermostatically controlled bath and an all-in-one kitchen module and table which would rise from the floor at the touch of a switch. This fresh use of materials and technology was exciting for a few years but was not taken up by a populist market and certainly didn't become the blueprint for 1980's living (except some have features such

Fig.8. 'House of the Future', 1956. Pencil on tracing paper. By Alison (1928–93) and Peter Smithson (b.1923).
V&A: E.663–1978

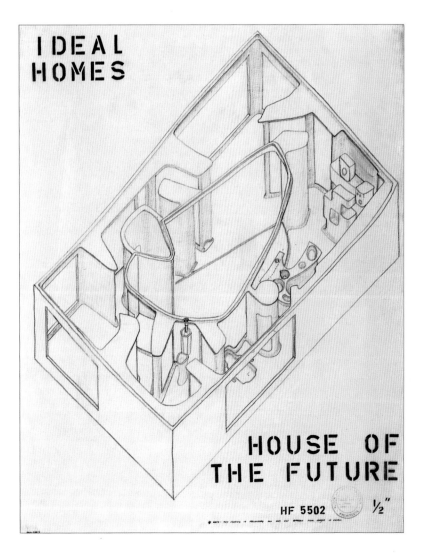

IDEAL HOMES

HOUSE OF THE FUTURE

HF 5502 ½"

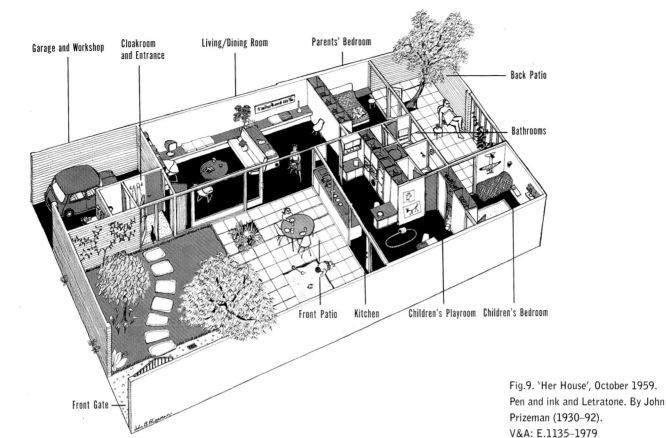

Garage and Workshop | Cloakroom and Entrance | Living/Dining Room | Parents' Bedroom | Back Patio | Bathrooms | Front Gate | Front Patio | Kitchen | Children's Playroom | Children's Bedroom

Fig.9. 'Her House', October 1959.
Pen and ink and Letratone. By John
Prizeman (1930–92).
V&A: E.1135–1979

as the thermostat-controlled baths). By the end of the 1950s the question of
how a perfect home should be laid out and look was still being debated. John
Prizeman's 'Her House' (fig.9) was a tangible answer to the question posed in
October 1959 in the *Daily Express* newspaper, 'Is your house your master or
your servant?'. Based on efficiency and convenience, it was seen to be a fresh,
forward-looking example of how the home could accommodate the needs of
the modern family and could be flexible to fit different pockets.

New lifestyles also resulted in the emergence of one-room living – in the
form of bed-sits and studio flats – to accommodate changing living needs and
habits for a younger, independent or smaller group home. First used in the
late 1920s and 1930s, they came into popularity in the 1950s and variants
were used for different housing needs, such as student accomodation,
throughout the century.

The 1960s saw the arrival of more first-time buyers, with the creation of
new satellite towns – a rejection by planners of the urban suburb. Pop art was
influential with its brightly coloured, challenging forms. Markets looking to
the future were consciously linked to the growing space exploration pro-
grammes. The cult of Space and all the forms and images, such as rockets and
planets, that went with it, found its way through styling and direct use of the

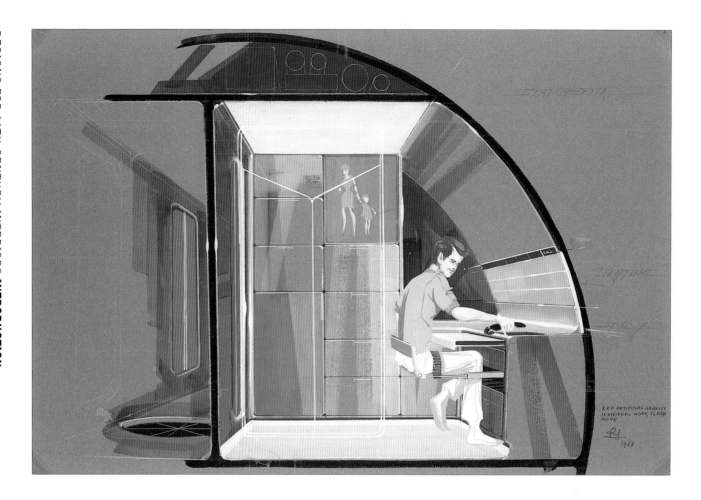

Fig.10. 'Stateroom in a spacestation',
1968. Postercolour, pen and ink, and
chalk on card. By Raymond Loewy
(1893–1986).
V&A: E.3203–1980

imagery into home decoration. The strong profiles and curving forms of 'space-age' styling, such as those by Raymond Loewy (1893–1986) in his 1968 design for NASA (fig.10), were copied in areas such as fitted-kitchen design. Flush surfaces and technological labour-saving gadgets were important to the housewife of the 1960s and 1970s.

In the 1970s, plastics finally became popularly accepted as alternatives to traditional materials such as wood and ceramics. There was an emphasis on comfort and convenience in home furnishing, and softer materials such as furry fabrics, cork for wall and floor coverings and shag-pile carpets were popular. There also began a reversal of the trend of the first decades of the century for people to live in suburbs or the country as a rejection of associations with industrialisation. The fashion for a return to urban living took the form of loft living in converted industrial buildings. First popular in Manhattan, New York, this lifestyle, which had connotations of the traditional artist's studio, embraced the industrial fabric of the building as a decorative feature. It also had the advantage of providing vast, unpartitioned living spaces, as against what were increasingly seen by an avant-garde set to be cramped conditions in townhouses and suburban semi-detached homes. The

technological look of 'Hi-Tech' (a play on 'high style' and 'technology') was also adopted in late 1970's/early 1980's flat-living, usually by men. 'Hi-Tech playroom for the 1980s' (fig.11), published in *The Observer* in June 1979, shows a work–play–living zone for the technology whizz kid of the 1980s.

By the 1980s this interest in the conversion, and also conservation, of industrial premises was swept up by the general wave of interest in heritage. Britain's architectural heritage, in the form of buildings of all ages and past uses, was seen to be under threat from the bulldozer of the town planner and developer. The importance of historical architectural features was key to the rise of Postmodernism (1970–90), which began in America at this time. This Revivalist style consisted of an assemblage of references to and derivatives from historical forms, but put together in new and modern ways. Some argued that it was so completely backward-looking that it had no currency in the last decades of the century. Postmodernists argued that as it was freed from rules of strict utility and historical conventions, it was a personal, poetic form, and that its irrational, inappropriate references brought an element of humour to design and architecture. Not restricted to architecture, there

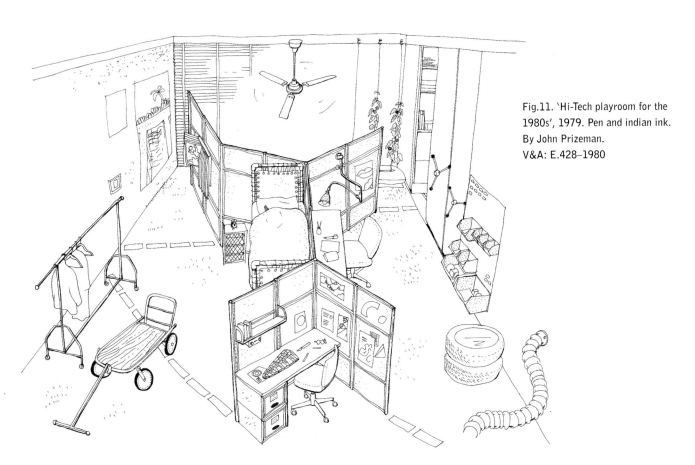

Fig.11. 'Hi-Tech playroom for the 1980s', 1979. Pen and indian ink. By John Prizeman. V&A: E.428–1980

were many designers, particularly in America and Italy, who used the Postmodern forms in household products and furniture. Both the Alchimia Studio and Memphis design groups in Milan, in particular, used the comical forms which confused expectations of size, materials and function, structure and decoration. They claimed that the forms allowed for an element of whimsy in design, giving it a freedom of form to express the eclectic character of the day, and although their products were highly controversial they were influential in international design of the 1980s.

Loft-living saw a dramatic increase in Britain during the 1990s. With the opportunities presented by the purchase of the bare and stark loft space, owners (using the services of interior designers and architects) had much more involvement and control in creating a personalised environment than with most traditional housing. Interesting uses were made of double-height ceilings and mezzanine floors. There was usually very little visual clutter of furniture or decoration in lofts, emphasising their spaciousness through white walls and unbroken sweeps of pale wooden strip floors. The open, minimalist interiors were usually decorated with a few choice pieces of contemporary designer furniture in bold, plain colours. Of course furnishings from previous accommodation were also used, and not all pieces were designed as part of an intended scheme or look. Etched glass, glass bricks and shiny chromium were used for their reflective and light-conductive qualities, emphasising the light and space and also making inevitable references to the Modernism of the 1930s. Lofts provided the ultimate challenge in flexible, multi-functional living spaces where functions no longer took place in pre-designated boxes. However, towards the end of the 1990s there was a growing tendency to start putting up walls, usually in pursuit of privacy, to partition off bedrooms and bathrooms. This was accompanied by the covering up of industrial elements, such as metal beams and joists, resulting in a more traditional-looking domestic environment. Perhaps the preferred elements that the homemaker wanted at the end of the century were not so far removed from those desired at the beginning.

The design process

The designs shown in this book demonstrate the many different stages of designing. All taken from the collections at the V&A, the drawings, print-outs and illustrations show how the design process itself has changed throughout

the period covered, and give an insight into the development from the idea to the product.

The sudden inspirational thought quickly scribbled onto a scrap of paper has a long and precarious journey through to production, if indeed it gets that far at all. A design has to pass the tests of function, materials and manufacture, as well as the demands of the market-place or patron, and at the end of the day it all rests on good timing. A good presentation drawing or rendering brings alive a design and is often important for selling a designer's idea. By looking at designs for furnishings and decoration of domestic interiors, this book will show how architects and designers envisaged the inside of houses and flats from 1900 to 1999. Because of the intrinsic nature of designs, they are not always fully realised in their original form. Some of these visions are flights of fancy and renderings of ideals and idylls, while others are more down-to-earth working drawings and innovative designs that actually saw production. As ideas evolve and metamorphosise, the final product can often bear little resemblance to the original idea, particularly with three-dimensional products; designs for flat goods such as textiles usually bear the closest resemblance, including colouring, to the finished product. (For the purpose of this book, designs for textiles – which could have been used in any room in the house – have been placed in the Living Room chapter.)

It is interesting to note that designers' and architects' drawings for domestic products and interiors rarely include people. Perhaps human form spoils the carefully composed and designed lines and forms of an object or space? In designs for interior decoration, where the focus is on the treatment of walls, floor-coverings and draperies, furniture is often left out of the picture. It is not until the marketing stage that objects and rooms are united in a more realistic context. This is the stage when products first meet their market, and prospective purchasers are encouraged to identify with the people in the adverts, as illustrated by the sales leaflet for the Wedgwood 'Blue Pacific' coffee pot on page 90. This sets up a conscious, or even unconscious image play, where consumers are expected to make their choices based on the self-conceptions of their own image, whether realistic or aspirational. And, as suggested earlier, at the end of the 20th century the design of products plays an important role in social image making.

Living Rooms

Over the past century the room or rooms in which we socialised in the home were continually changing in size, shape and look. As their functions were redefined by changes in lifestyles, the layout of reception and sitting rooms was reduced from a number of single rooms divided by walls, each with a formal use assigned to them, to open-plan multi-functional spaces.

In superior middle-class homes at the beginning of the century, the main 'public' room would have been a drawing room, in which unexpected visitors and guests would have been received. Originating as a ladies' after-dinner withdrawing room, when gentlemen were left to their own company around the dining table, it was primarily a female domain, and would traditionally have been decorated and furnished in a feminine manner with the best quality items that the household could afford. The dining room, along with the billiard room, was thus the male domain, as reflected in their often darker and heavier furnishings. The less well-off middle classes would have had a parlour with a similar social function to the drawing room. Usually at the front of the house, it was also kept as the 'best' room, and was used only for entertaining visitors on special occasions. The family would have gathered in another room for daily use, called the sitting room or living room, terms first used at about this time. The females of the house might also have had a morning room in which they took their breakfast.

Early 20th-century writing on social etiquette in the home included hints on tasteful decoration and furnishings. In 1920 the increasing practice of families to use their dining room as a living room was frowned upon by R. Randal Phillips who, in *The Servantless House*, suggested that these people should eliminate the sitting room in favour of one large living room. But the commentators were all in agreement that the main intention when creating a 'home' was that it should be made 'comfortable'. The popular notion of the home as a retreat and somewhere to spend time with the family, and to entertain, had begun in the 19th century. The decoration and furnishing of the drawing room, sitting room, lounge or living room therefore became important as part of the process of self-expression and definition of the style or atmosphere of a home.

With the general decrease in the urban house size, and therefore of the individual rooms, architects and designers had to create new ways of living with multi-functional spaces with flexible furniture. This was particularly

noticeable after the First World War, when the availability of servants to help with domestic chores declined, the house-buying market grew, and issues of improved hygiene and new technology entered the home. The spread of domestic electric lighting in the first decade of the 20th century had great implications on the way homes looked. Lights were instantly brighter and gave off a more even, white light than candles. The advantage of having them placed in the centre of the ceiling was widely recognised and large lamps, or electroliers, with many bulbs, sometimes emulating chandeliers, were fitted, often with matching wall-mounted sconces.

The great thing after all is to have sensible rooms that look as though we really used them and enjoyed living in them, with furniture that meets our everyday requirements, and with just sufficient ornaments or other features of decoration that add an element of gaiety and refinement.

R. Randall Phillips, *The Servantless House* (1920)

The introduction of electricity and gas for heating also had the effect of lightening living rooms, although, mainly for financial reasons, they were not initially connected to as many homes as electricity for lighting. The need for dark, busy patterns in wallpapers and furnishing fabrics to hide smoke smuts and marks on walls, floors and fabrics was gone, and from about 1911 colours became lighter and more adventurous – paler, creamy colours were used in wallpapers and furnishings. This resulted in the almost instant rejection of the heavy, dark Arts and Crafts and patterned Art Nouveau styles for reception rooms. The new forms of heating also meant that the main source of heat was not fixed by an architectural element, i.e. the chimney. With the introduction of oil storage heating in the early 1930s, there was even less need for a fixed heat source and so designers and dwellers had more freedom in the arrangements of furniture in the living room.

Central heating was particularly important for the increasingly popular practice of building blocks of flats as urban dwellings during the late 1920s and 1930s. Usually having a relatively small floor space, the living room was like a shell in which many different activities took place, and so it was advantageous to be able to move around with an even spread of temperature.

The tall blocks lent themselves easily to the straight, unfussy lines of the International Modernist style, which most of them took on. Not all of the occupants continued the Modernist forms inside their flats, however, and while many chose the new uncluttered look of simple Modern furnishings, or the more rounded forms and plush, rich colours of Art Deco, there was still a market for traditional period furniture in new modern homes.

The smaller, space-conscious rooms, however, demanded less bulky furniture, which had to be practical and look good. In the mid-1920s, designers started using materials which were offshoots from industry, such as tubular steel and treated glass and mirror, as well as traditional wood, leather and canvas and later plywood, in an endeavour to create new types of furniture for the requirements of the new life-styles. In Britain, less bulky, well-made and economical furniture was being designed and produced by some manufacturers, such as Gordon Russell Ltd. Based on the British tradition of truth to materials, and influenced by Modern and Swedish design, which began to spread across Europe and America in the 1930s, these developments were taken forward in the Utility furniture of the Second World War. The serious lack of raw materials in Britain in 1941, which had resulted in the establishment of the Utility Furniture Scheme chaired by Gordon Russell (1892–1980), led to tight controls on the amounts of wood used in making furniture and greatly influenced the look of products for over a decade.

After furniture restrictions were removed in 1953, there was an immediate surge in demand for elaborate, traditional furniture, as many Britons returned to historical tastes and fashions in an attempt to redefine their national cultural position. This was soon influenced by the more simple forms of Scandinavian and particularly Danish Modernism, which combined the use of traditional materials, such as solid wood and leather, with slender, elongated elegant forms. The use of stained and polished teak was a popular element in this fashion for natural materials in furniture. It also celebrated natural textures in materials such as wood, exposed brick and hessian, which were used in wall and floor coverings. This was juxtaposed with the mid-1950's desire for brightly coloured textiles and fittings. Heavily influenced by the influx of new American-styled goods, with their brash, bright, slim and modern, fresh feel, they provided a colourful contrast to the more neutral, natural finishes. Officially promoted by the Council of Industrial Design and at the 1951 Festival of Britain, they were popularly taken up in most living rooms.

As outlined in the Introduction, it became popular across Europe and America for architects to open up the dining room and sitting room into one large through room to provide an increased sense of space. This was important in the new, even smaller suburban houses of the post-war years, and this larger living area was soon added to by the integration of the hall and staircase. This open-plan layout with living/dining rooms, or sometimes diner/kitchens, required clever planning in layout and arrangement. Furniture also needed to take up less space and became lighter framed, using more plastic and steel and less fabric drapery. In the 1960s, bright, bold colour became a dominant feature in home decorating and, with the increase in the use of moulded plastics and laminated surfaces, by the mid-1960s living rooms were pools of Pop, space-age, psychedelic swirls. Developments in space architecture influenced the domestic sphere and resulted in the challenge of floor levels, with rooms having several different levels and sunken 'living-pit' seating areas. In more traditional furniture areas, this period saw the emergence of the standard three-piece suite of furniture, which became a staple form of living-room seating for the rest of the century.

These movements continued into the 1970s, with more plastic-made accessories and furniture. With the addition of period revivals, including sparsely furnished, pine wood, cottage-type furnishings, the 1970s also saw the beginnings of the trend in turning industrial warehouses into living spaces. The original Manhattan loft conversion, complete with exposed industrial beams, had the advantage of uninterrupted, high-ceilinged spaces in which living, cooking, bathing and sleeping took place without walled divisions. Increasing in popularity throughout the 1980s, loft conversions came into their own in Britain in the 1990s with the return to fashion of urban dwelling. By the end of the 1990s, however, the trend was once again towards putting up walls to create private areas. It seems that the practical need to divide some domestic activities by the traditional methods was stronger than the draw of unbounded living space.

One continuous feature throughout the living room designs of the 20th century is the popular presence of the house-plant or vase of flowers. Whether they are roses in the Edwardian drawing room, daffodils in the Tudorbethan dining hall, a spiky cactus in a Modernist sitting room, a potted Monstera in a 1970s open-plan living room, or a mini-garden at the core of a modular living space, there was a constant need for contact with nature inside the home.

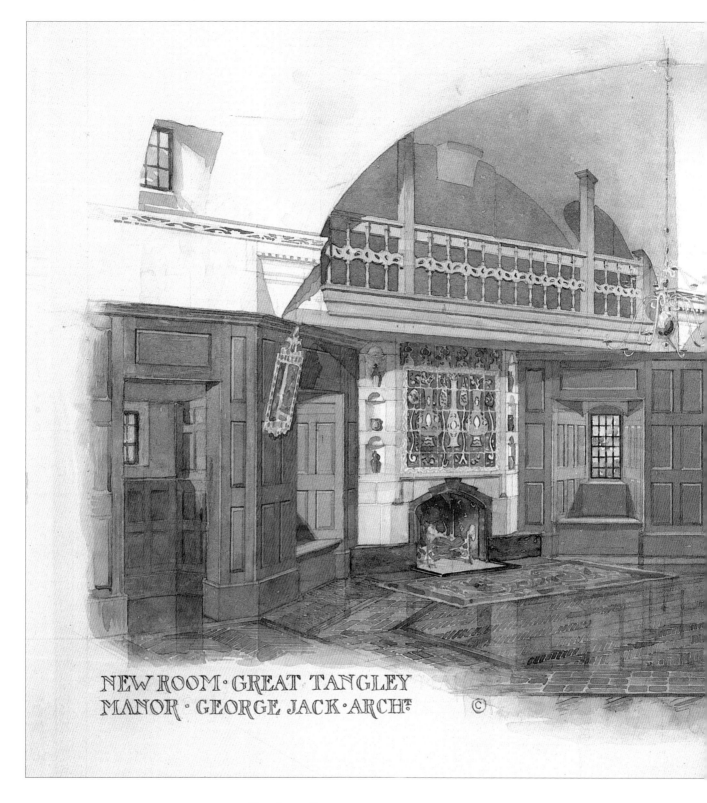

NEW ROOM · GREAT TANGLEY
MANOR · GEORGE JACK · ARCHT

1 Design for a new
 room at Great
 Tangley Manor, 1902

George Washington Henry Jack
(1855–1931)
Pencil and watercolour
V&A: E.612–1972

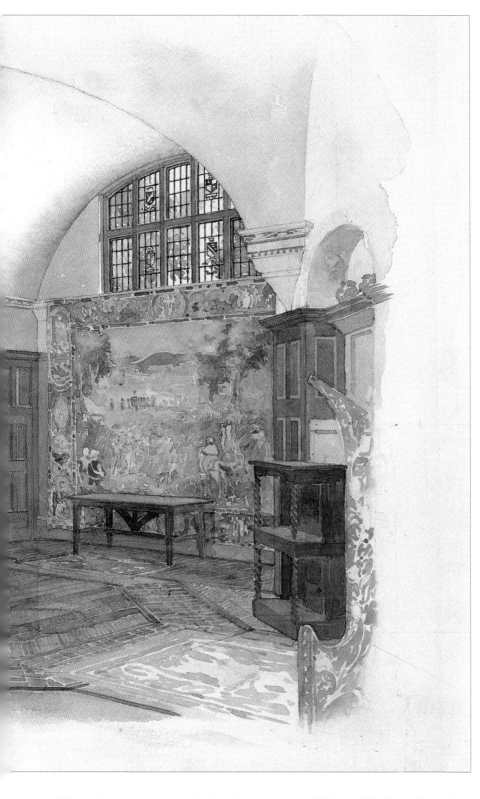

attempt to recreate the medieval Great Hall, Jack designed a large, lofty space (complete with minstrel's gallery) which would traditionally have been multi-functional. With a large fireplace as a focus, it is furnished with dark wood panelling and a simple oak dining table and cupboard, but with the latest in upholstered cosy-corner seating, which can just be seen on the right. The medieval, baronial look given by the leaded stained-glass windows, complete with chivalric coats of arms, and a large hanging wall tapestry is contrasted with the fashionable use of Eastern-influenced tiles decorating the fireplace. This emphasises the perpendicular form of the fireplace, which was the trend during this period. The tiles and rugs are in the blues, greens and soft pink that were made popular through the enamelled silverware of Liberty & Co. at that time. The banisters of the minstrel's gallery and the central ceiling lamp have been given the more delicate, spindly Art Nouveau treatment. *The Architectural Review* (1902, p.196) described it as 'a beautiful room, every part of which has been felt and seen and worked out'. The writer then goes on to praise the quality of Jack's drawing: 'The colour scheme as shown on the watercolour drawing – an exceptionally able and sympathetic specimen of its kind, by the way – helps to complete the harmony there is between the materials and their purpose, and the attractive homeliness of the room'. Although known for his skill in wood-carving, Jack had originally intended to be a painter.

This design was shown at the Royal Academy in 1902 and demonstrates George Jack's great debt to Philip Webb (1831–1915) and William Morris (1834–96), for whom he designed furniture. A scheme for a new addition to Wickham Flower's country home in Surrey, the design shows an early Edwardian combination of Arts and Crafts forms and the more affected, elongated, elegant style of Art Nouveau. In an

2

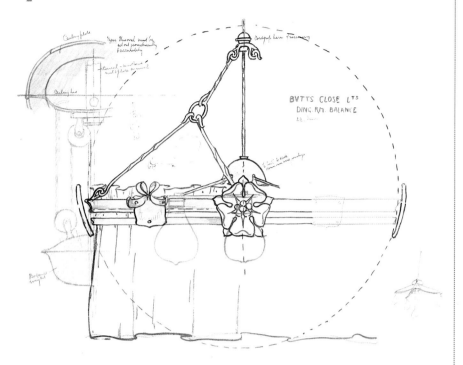

BVTTS CLOSE Lᵀˢ
DING. RM. BALANCE

Designs for electric lamps for the Library, Butts Close, *c.*1904

Nelson Ethelred Dawson (1859–1942)
Pencil and watercolour
V&A: E.739–1976

Electric lamps had no precedent styles to inform their look, and so offered designers the opportunity to create an original form for this new source of light. Without the danger of a naked flame, electric lamps didn't need the same type of shades as candles, oil lamps or gasoliers and so at first they appeared rather naked in contrast. As can be seen here, the designer was attempting to accommodate the flex and the fittings while keeping the whole effect elegant. With the flower-like exposed bulbs and tendril-shaped metal fittings, the designer is drawing on plant forms much in the style of Art Nouveau. At first these lamps were

often set in places traditionally used for candles, oil and gas lights, such as on the walls in sconces or candle stands, and in the ceiling in the centre of the room. Electric lights didn't produce as much heat as candles and at first there was a noticeable decline in warmth in many homes. They were, however, seen to be more convenient as they didn't have to be lit and snuffed out, and didn't leave smoke and soot smuts on the wallpaper and furnishings. Electric light was a much brighter, whiter light than its predecessors and the practical effect on both decoration and society was radical. While, after 1910 wallpapers began to be lighter and plainer in decoration, women were warned that the glare of the light was not complementary to their complexions.

3 (right)

Design for door and wall panels for 3 Albert Road, Regent's Park, *c.*1926

Duncan Grant (1885–1978)
Pencil and bodycolour
V&A: E.159–1982

This design for a wall and door decoration treatment, which was commissioned by and executed in the home of Mrs St John Hutchinson, is a typical example of Duncan Grant's painterly, animated, florid manner and his use of classical motifs. The colours used here are much more muted than the striking bright colours used in the first years of the Omega Workshop. Originally a leading member of the Omega Workshops, which operated in London and Sussex between 1913 and 1919, Grant set up a firm in 1922 with Vanessa Bell (1879–1961), also from the Omega studios, designing 'decorations domestic ecclesiastical theatrical'. They continued to practise in much the same manner established by the Omega studio, which was heavily influenced by artistic movements in France such as the Fauves. In 1913 Omega had introduced a startlingly new note of spontaneity, abstract design and freshness into interior design and decoration in Britain. The artists and designers applied this new artistic language and practice to decorate domestic, often conventional furniture as well as walls, panels and fixtures. They left

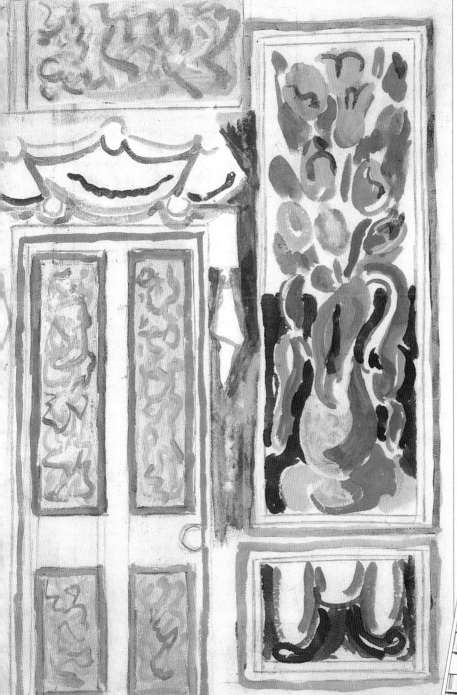

They left no surface untouched by their paint brushes ... loose modern patterns and paintings.

Photograph of the drawing-room with completed interior, reproduced in D. Todd and R. Mortimer's *The New Interior Decoration* (1929, pl. 76)

no surface untouched by their paint brushes, wallpapers or textiles, which had loose modern patterns and paintings. Although their productions were mainly, for economic reasons, taken up by the upper-class and aristocrats, their attitude to decoration was more influential. By the late 1920s, however, young artists and designers had moved on, and with the influence of the plain-walled, simply decorated furnishings of International Modernism, the highly decorative style of the Omega Workshops went out of fashion.

4

Drawing room, *c.*1928

William Henry Haynes & Co.
Pencil and watercolour on board
V&A: E.6–1977

The decoration firm of William Henry Haynes & Co. offered the latest in traditional period schemes, revived and adapted for the smaller domestic environment but with modern touches. The early Georgian panelling, including an elaborate fireplace, is stripped in the fashion of the unhistorical preference of the day. This taste was influenced by a display of 18th-century panelling at the V&A in the mid-1920s, in which the paint on the panelling had been intentionally removed to reveal the surface of the wood and the technique of the carving underneath. The reproduction early 18th-century furniture, including the 'Knole sofa', is tempered and mixed with the fashionable exotic taste for Japanese lacquer screens. Another modern touch in this historical setting is the introduction of new craft pottery lamps: replacing traditional lighting, one sits on an old candle-stand next to the fireplace, the other on an 18th-century tea table.

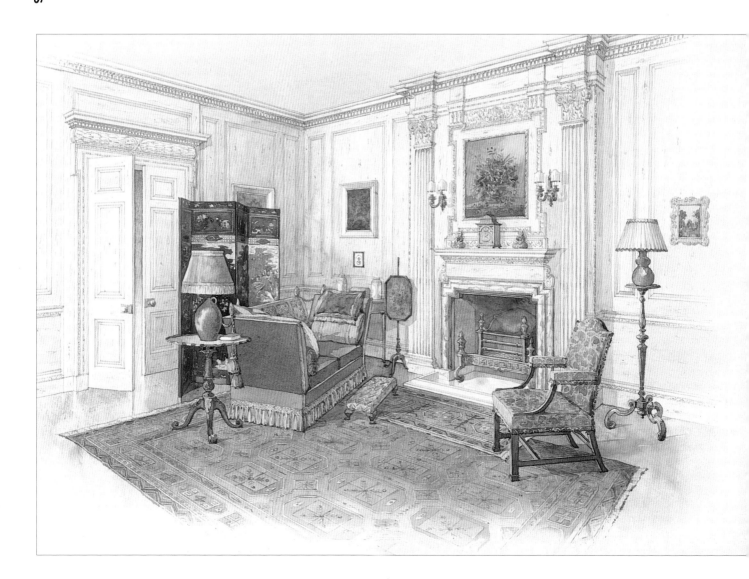

'Fantasy' textile design, 1927

George Walton (1867–1933)
Pencil, pen, watercolour and collage
V&A: E.343–1974

This partly coloured design is a pastiche of popular motifs of the day. Influenced by the bright and vivacious designs of Leon Bakst for the Ballets Russes, it has an air of theatricality veering towards the surreal. The dream-like sequence of exotic characters includes sleeping nymphs, oriental trees, harlequins and Pierrot, taken from French pantomime. Such figures were frequently portrayed in paintings and sculptures in the late 1920s, which were popularly displayed in Art Deco interiors. Other sources for whimsical creatures and settings can be found in the 'Dragon' lustreware and 'Fairyland' lustreware, decorated by Daisy Makeig-Jones and produced by Wedgwood from 1914.

Originally an architect of the Glasgow School, Walton became more interested in the qualities of pattern in interior decoration. Working mostly for mainstream textile manufacturers, such as Morton's, Walton continued the popular traditional patterns of the period in his work.

Influenced by the bright and vivacious designs of Leon Bakst for the Ballets Russes ... an air of theatricality veering towards the surreal.

6 (opposite)

Design for 'Transat' chair, c.1924–27

Eileen Gray (1878–1976)
Pencil on tracing paper
V&A: E.1130–1983

This rendering (opposite), showing a side elevation and plan for the folding 'Transat' (short for *Transatlantique*) armchair, is a prime example of Eileen Gray's distinctive sharp and linear drawing style. It emphasises the straight lines of the chair frame, which form a contrast with the curve of the seat, seen here with the padded shape of the leather-covered version. The 'Transat's rigid lacquer frame, with chromed-steel fittings and padded leather seat, were radically different and distinctively Modern. Influenced by Mies van der Rohe's chrome-plated metal chair of 1927, which was something of a revelation with its cantilevered floating seat, Gray was one of the first designers to use chrome-plated metal. Producing practical and elegant furniture which epitomised International Modernism of the late 1920s and 1930s, Eileen Gray used a wide range of new and traditional materials, including glass, wood and leather. As a practising architect, she was interested in developing the ideal Minimal Dwelling and was concerned that furniture should be flexible and convenient for the small urban home. As such, the 'Transat' could easily be folded and stored out of the way when not in use.

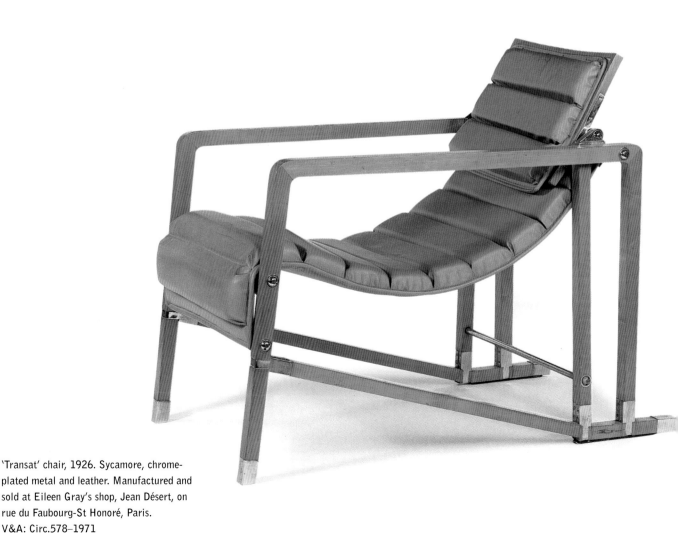

'Transat' chair, 1926. Sycamore, chrome-plated metal and leather. Manufactured and sold at Eileen Gray's shop, Jean Désert, on rue du Faubourg-St Honoré, Paris.
V&A: Circ.578–1971

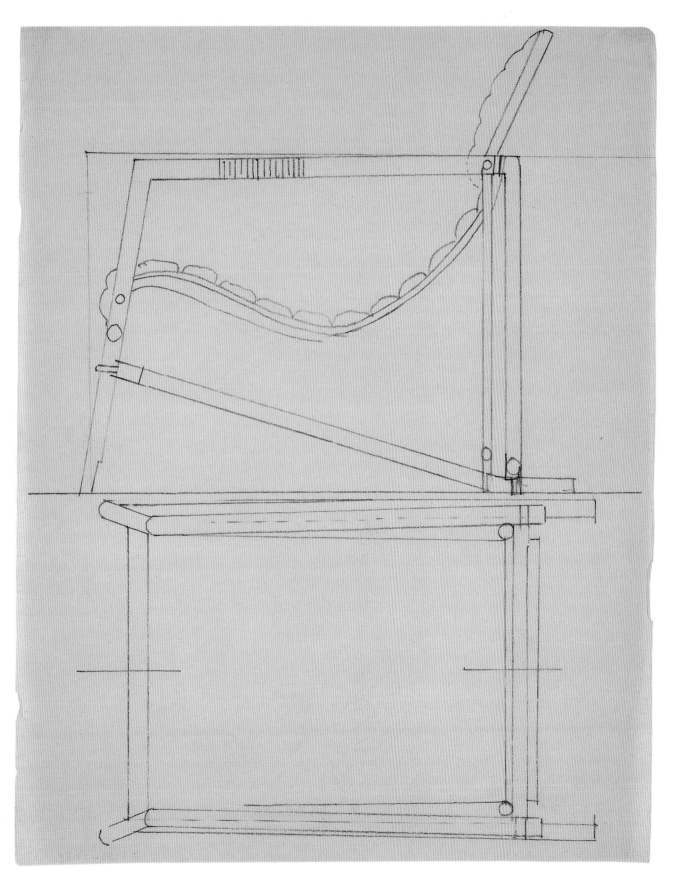

Design for wall elevation with settee and light fittings, c.1930

Anonymous Belgian designer
Pencil, watercolour and bodycolour
V&A: E.2204–1992

High-style Art Deco was most popular in Continental Europe. This Art Deco treatment of furnishings and a wall demonstrates the richness of colours and materials used in this luxurious style, found particularly in Belgium and France. The decoration of the wall with neat rectilinear forms complements the rich brown tones of the walnut doors, which no longer have detailed mouldings. In contrast, the wall-mounted light fittings embellished with sharp transverse metal bands are products of the machine aesthetic design, which reflects the respect for new materials and technology. The contrast of the green piping around the cream settee emphasises its neat square lines, the colours taken from oriental jade carvings. The side tables with shelves echo the stepped lines of the light fittings which are balanced on either side of a modern landscape painting. The overall effect is one of rich, opulent styling in a luxurious environment.

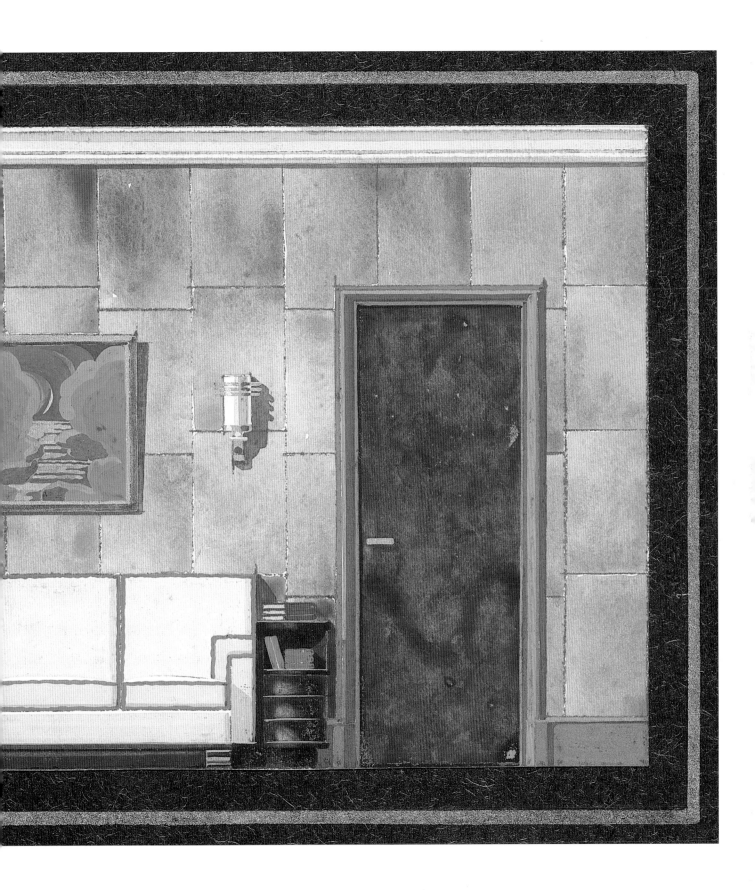

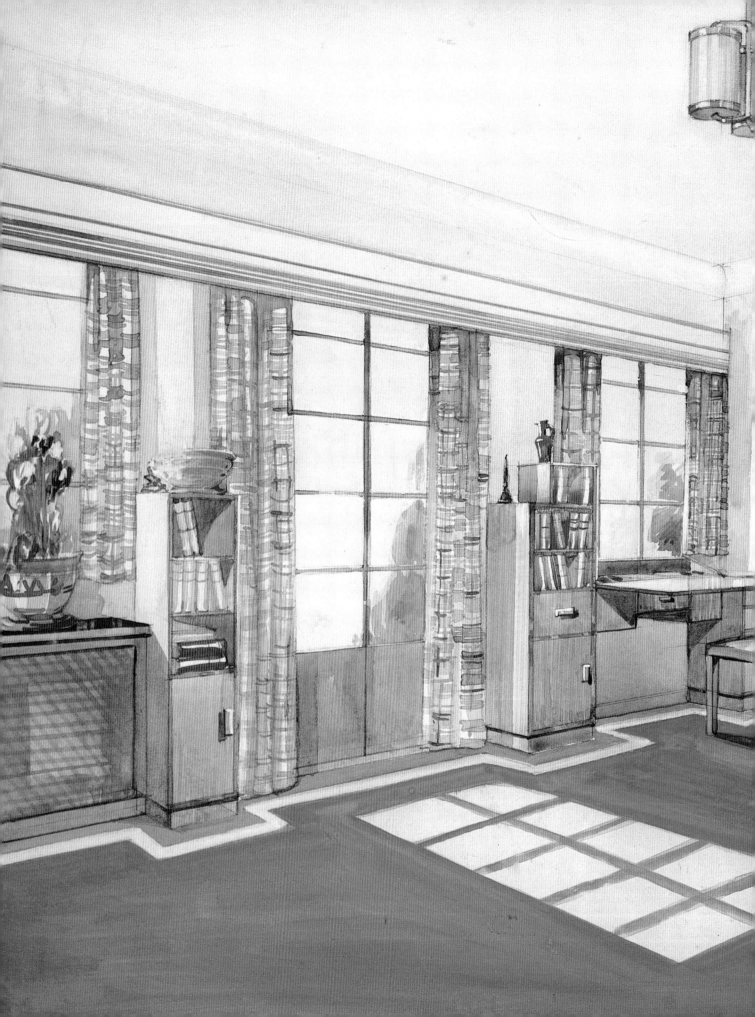

8

Drawing room design, c.1930

Harvey Nichols Ltd.
Pencil, watercolour, bodycolour and
Chinese white on board
V&A: E.2427–1983

This presentation drawing for a drawing room in Ealing, probably for a flat, is by the upmarket firm of Harvey Nichols Ltd., Knightsbridge, London, and demonstrates the respectable, accepted influence of Modernism in the middle-class British domestic interior. It is obviously a recently constructed building, fitted with the new wider, metal-framed windows and with the French window feature. The new concrete construction methods of building in the 1930s meant that walls were no longer load-bearing and so windows could be larger than before. The fashion for plain walls gave prominence to the window forms, which became a decorative feature of the room. This resulted in the stylistic play on the horizontal lines, emphasised by the arrangement of the glazing bars, which was continued in the internal furnishings through the neatly fitted shelving. Although the walls and carpet are plain, they have soft, traditional colours, and the pale ceiling and walls reflect and emphasise the natural light. The settee is upholstered in a modern abstract pattern which matches the shade of the nearby standard lamp. The ceiling light fitting is a radical addition, with its cluster of cylinders made in shiny chrome and glass, and is a token to the machine-age aesthetic in an otherwise restrained Modern living room.

The new concrete construction methods of building in the 1930s meant that walls were no longer load-bearing and so windows could be larger than before.

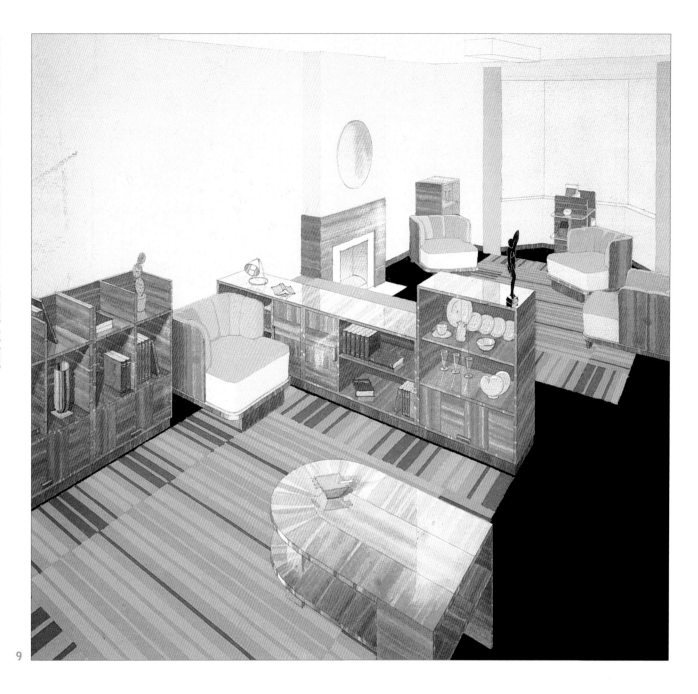

9

Design for a living room, *c.*1933

Raymond McGrath (1903–77)
Pencil, bodycolour and metallic
pigment
V&A: Circ.563–1974

Raymond McGrath's design for a
living room is a combination of rich
Art Deco with constrained Modernist
forms. Unpainted woods, from Finnish
blond-wood to Australian mahogany,
were popular in Modern interiors.
The richness of the grained wood gives
a warm and exotic feel to the room
and contrasts with the straight lines of
the furniture and rug patterns. The
layout of the room itself is a departure
from tradition. Probably intended to
be a dining room and sitting room, the
space is divided by low modern units,
and the fireplace at the far end of the
room has been removed from its
traditional central position as the focus
of the room. McGrath, an architect
who came to Britain from Australia in
1926, worked on both residential
properties and on public buildings,
such as London's Broadcasting House.
However, his International Modernist
brand of design, though elegant, was
too radical for the mostly conservative
tastes of British householders.

Design for a Bakelite radio cabinet for EKCO Ltd., 1934

After Raymond McGrath
Pen and pencil on tracing paper
V&A: E.554–1974

This radio cabinet design is one of a group designed by Raymond McGrath, and drawn by a studio hand, probably for selection by the manufacturer (although this model does not appear to have been made). It shows the developing style for radios in the late 1930s, which was moving away from the more crude, industrial-looking radio sets previously available. The upright body with rounded edges has a distinctively Art Deco look, whilst the grid-form grill and neat round knobs on the front give it an almost personified appearance. Radios were prize possessions at this time. Either built-in or in a separate casing, they took a prominent position in the living room on a table, or smaller models on the mantelpiece – hence the desire for them to look more like respectable, elegant pieces of domestic furniture than machines.

Bakelite was the first totally synthetic plastic. Developed in America, it was commercially produced from 1916 and it created the plastics compression moulding industry. In Britain it was used extensively in dark colours, as a cheap substitute for wood in goods such as radio cabinets and pens; in America it was more popularly used in bright colours. Bakelite was useful for its hard exterior, however its tendency to become brittle led to its fall from popular use.

Design for a rug for the Wilton Royal Carpet Factory Ltd., 1930s

Marion Dorn (1899–1964)
Pencil and watercolour on prepared board
V&A: E.2268–1992

Marion Dorn was a prolific designer of carpets and textiles, using Modernist abstract motifs. Working in London during the 1930s with her husband, the avant-garde artist and designer Edward McKnight Kauffer (1890–1954), Dorn was the best-known carpet designer in Britain. She led the field in developing high quality carpets, emulating the French luxury market but with new Modern designs. Rugs, often laid on wooden parquet floors, became a focus in new living rooms, as can be seen in Raymond McGrath's design for a living room (plate 9). They came into fashion because of a revolt against fitted carpets on the grounds that they harboured potentially harmful dust and bacteria. This design is typical of her style, usually intended for hand-knotted rugs, which had plain, neutral backgrounds with a few muted colours and strong directional lines or abstract forms, and which suited the plain, streamlined interiors of the period. Her trademark style was the cream-on-cream carpet with a geometric relief in the weave, as used in Syrie Maugham's (1879–1955) famous all-white room of 1933. However, like many designers Dorn also produced designs in traditional styles, as companies such as Wilton's supplied for both the modern and traditional market tastes.

12 (opposite)

Design for a reclining chair for Isokon, 1936

Marcel Breuer (1902–81)
Pen and ink on oilcloth
V&A: Circ.231–1975

This is one of the original designs for the plywood 'Long' chair. Breuer experimented with this type of lounge chair, based on the original form by Le Corbusier (1887–1965) and Charlotte Perriand (b. 1903), and also designed a version in tubular steel.

A later version in sycamore designed for Heal's, London, seen here in the Heal's catalogue, had a slightly chunkier construction design. Shown in a living room setting with a modern, cantilevered bureau, the look was advertised as being spacious

and uncluttered, and thus 'the house-maid's sweeping is simplified'. Breuer was particularly interested in the possibilities of plywood for furniture. In 1925 he stated: 'The thin sheet of veneered plywood is unpopular

Right: Heal's Mansard Gallery exhibition catalogue, *Contemporary Furniture by 7 Architects*, showing a living room designed by Breuer with a variation of the 'Long' chair. 1938, p.5.
V&A: L.1724–1982

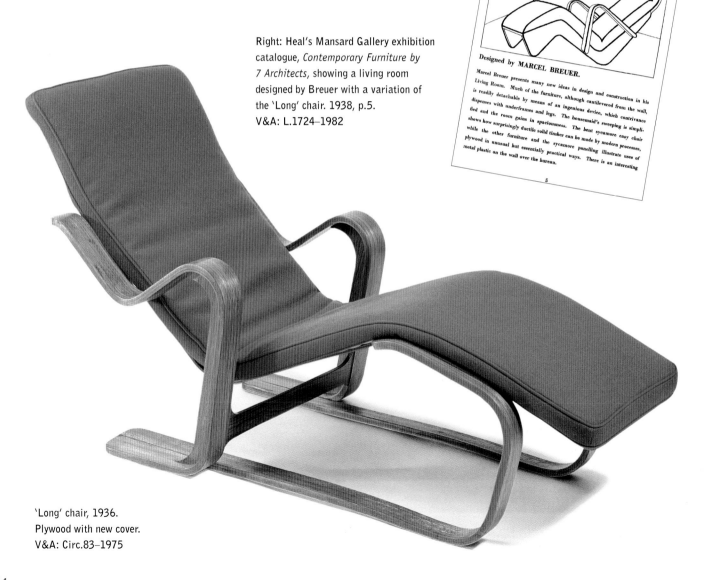

LIVING ROOM
in Sycamore

Designed by MARCEL BREUER.

Marcel Breuer presents many new ideas in design and construction in his Living Room. Much of the furniture, although cantilevered from the wall, is readily detachable by means of an ingenious device, which contrivance dispenses with underframes and legs. The housemaid's sweeping is simplified and the room gains in spaciousness. The bent sycamore easy chair shows how surprisingly ductile solid timber can be made by modern processes, while the other furniture and the sycamore panelling illustrate uses of plywood in unusual but essentially practical ways. There is an interesting metal plastic on the wall over the bureau.

5

'Long' chair, 1936.
Plywood with new cover.
V&A: Circ.83–1975

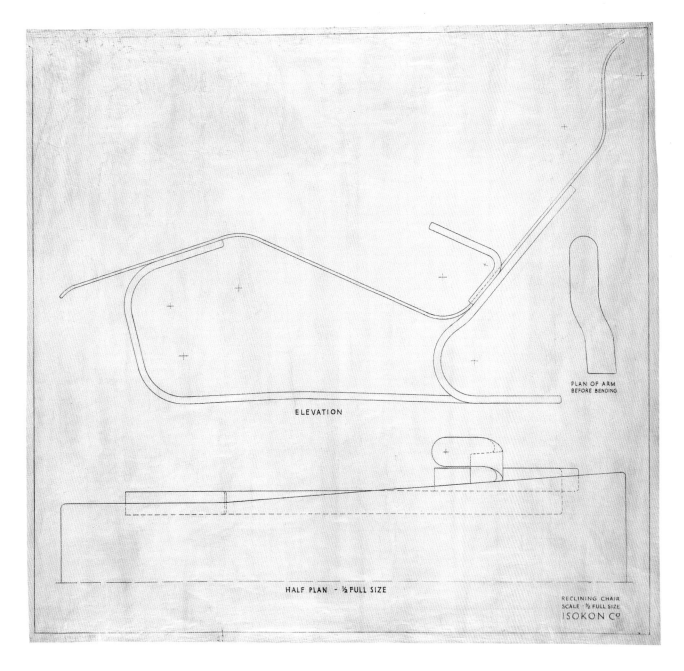

ELEVATION

PLAN OF ARM
BEFORE BENDING

HALF PLAN · ½ FULL SIZE

RECLINING CHAIR
SCALE · ½ FULL SIZE
ISOKON Cº

among professionals because it is an unreliable material, but nevertheless has great potential for development and in my opinion is the material of the future for the furniture industry – with the aid of clever construction it can be tamed today…' (*The Bauhaus Masters and Students by Themselves*, ed. Frank Whitford, 1992, p.228). The potential of plywood was first realised in the aircraft construction industry during the First World War, where its properties for resilience

and lightness were noted – it has a much greater tensile strength in all directions than simple wood. Breuer experimented with plywood at the Bauhaus workshops, where he was a well-established designer, architect and teacher.

When he came to Britain in 1935, he worked for Jack Pritchard at the Isokon Company, which specialised in producing plywood furniture for the British market.

… in my opinion [plywood] is the

material of the future for furniture …

13 (right)

Components of a utility armchair, 1948

Anonymous illustrator for Board of
Trade catalogue, *General Specification
for Utility Furniture*
V&A: E.640–1999

Below: Utility lounge chair, after 1948.
Wooden frame and replaced fabric upholstery.
V&A: W.13–1976

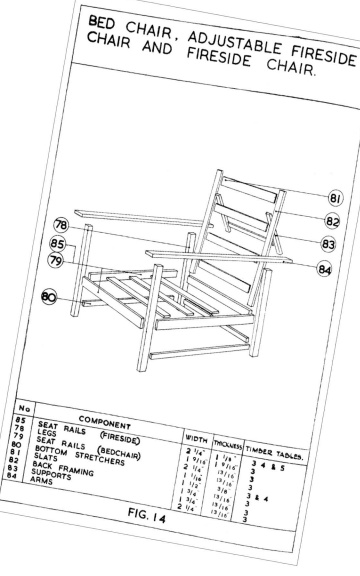

BED CHAIR, ADJUSTABLE FIRESIDE
CHAIR AND FIRESIDE CHAIR.

No	COMPONENT		WIDTH	THICKNESS	TIMBER TABLES.
85	SEAT RAILS	(FIRESIDE)	2 1/4"	1 1/8"	3 4 & 5
78	LEGS		1 9/16"	1 9/16"	3
79	SEAT RAILS	(BEDCHAIR)	2 1/4"	13/16	3
80	BOTTOM STRETCHERS		1 1/16"	13/16	3
81	SLATS		1 1/2"	3/8	3 & 4
82	BACK FRAMING		1 3/4"	13/16	3
83	SUPPORTS		1 3/4"	13/16	3
84	ARMS		2 1/4"	13/16	3

FIG. 14

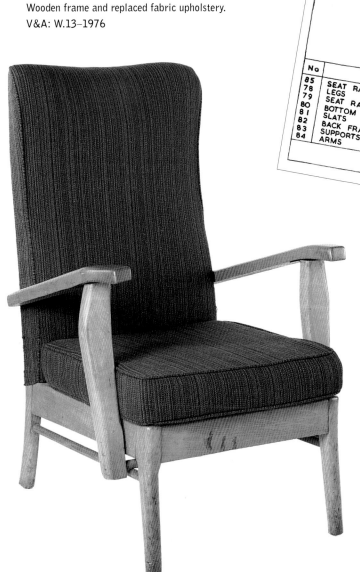

There was very little
decoration or moulding
on furniture supplied
through the Scheme,
and details that required
the use of extra wood
were prohibited.

This illustration (left), demonstrating how to construct a Utility armchair, clearly shows the plainness of the form and the efficiency in the use of the materials that was intended by the Board of Trade Utility Scheme. There was very little decoration or moulding on furniture supplied through the Scheme, and details that required the use of extra wood were prohibited.

The Utility Scheme was set up in 1941 as a result of the wartime scarcity of raw materials in Britain. In an effort to ensure the fair distribution of materials across the country and to guarantee a good production standard of furniture, the government restricted wood supplies and then regulated the furniture that was made. An exact set of design specifications was formulated through the government Board of Trade Utility Furniture Advisory Committee, chaired by Gordon Russell, and issued only to those manufacturers holding a licence. In January 1943 the first catalogue of *Standard Emergency Furniture* was published, announcing the forthcoming availability of furniture which was to be supplied to anyone who had been bombed out, or to newlyweds setting up home. Utility regulations affected furniture design at all levels for more than a decade. In November 1948 Freedom of Design was announced, which allowed manufacturers to design their own furniture while adhering to the limits imposed for the carcass construction of the original range. Furniture manufacturers and designers continued to be restrained for a further five years until the Utility Scheme finally ended in January 1953.

Illustration from Utility furniture catalogue, 1943.
V&A: NAL

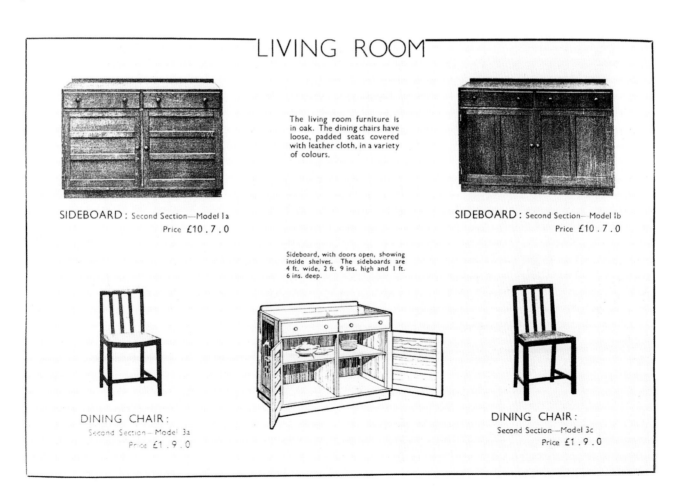

LIVING ROOM

SIDEBOARD : Second Section—Model 1a
Price £10 . 7 . 0

The living room furniture is in oak. The dining chairs have loose, padded seats covered with leather cloth, in a variety of colours.

SIDEBOARD : Second Section— Model 1b
Price £10 . 7 . 0

Sideboard, with doors open, showing inside shelves. The sideboards are 4 ft. wide, 2 ft. 9 ins. high and 1 ft. 6 ins. deep.

DINING CHAIR :
Second Section - Model 3a
Price £1 . 9 . 0

DINING CHAIR :
Second Section—Model 3c
Price £1 . 9 . 0

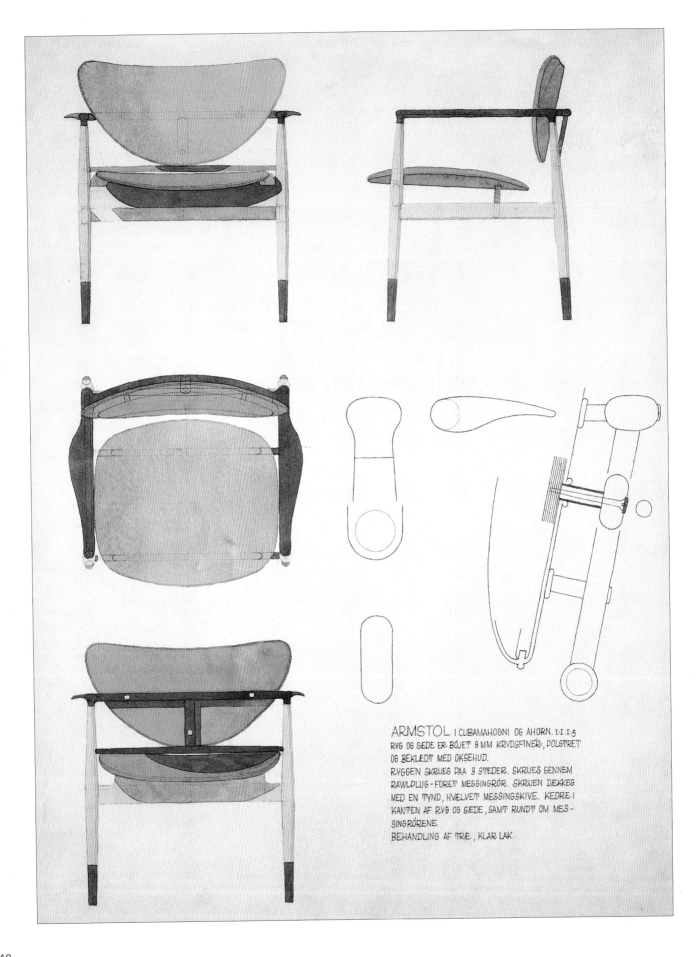

ARMSTOL I CUBAMAHOGNI OG AHORN. I:I:5
RYG OG SÆDE ER BØJET 8 MM KRYDSFINER, POLSTRET
OG BEKLÆDT MED OKSEHUD.
RYGGEN SKRUES PAA 3 STEDER. SKRUES GENNEM
RAWLPLUG - FORET MESSINGRØR. SKRUEN DÆKKES
MED EN TYND, HVÆLVET MESSINGSKIVE. KEDRE I
KANTEN AF RYG OG SÆDE, SAMT RUNDT OM MES -
SINGRØRENE.
BEHANDLING AF TRÆ, KLAR LAK.

Design and elevations for an armchair, 1948

Finn Juhl (1912–89)
V&A: Circ.460–1970

One of the leading proponents of restrained Danish design, Finn Juhl was the first to move away from 1930's Danish Functionalism. Through commissions, exhibitions and competition awards in Scandinavia, Italy and America, he was largely responsible for putting Danish design into the International arena along with Scandinavian design, which had already been receiving much attention since the 1920s. Denmark captured the late 1940's and early 1950's market for well-designed, factory-made, cheap solid-wood furniture. This design clearly shows the 'floating seat' structural technique, where the seat rested on crossbars rather than the chair frame. Influenced by the forms of Jean Arp and by African sculpture, Juhl produced minimal structures with rounded, softened edges. The design is inscribed with the construction instructions which indicate that the armchair was intended to be made of wood in contrasting Cuban mahogany and sycamore. This was to be finished with a clear varnish and with a leather back, as you can see here in the settee version below. Juhl later introduced the 'floating seat' construction into his furniture range for Baker Brothers Furniture of Grand Rapids, Michigan, USA, in 1951.

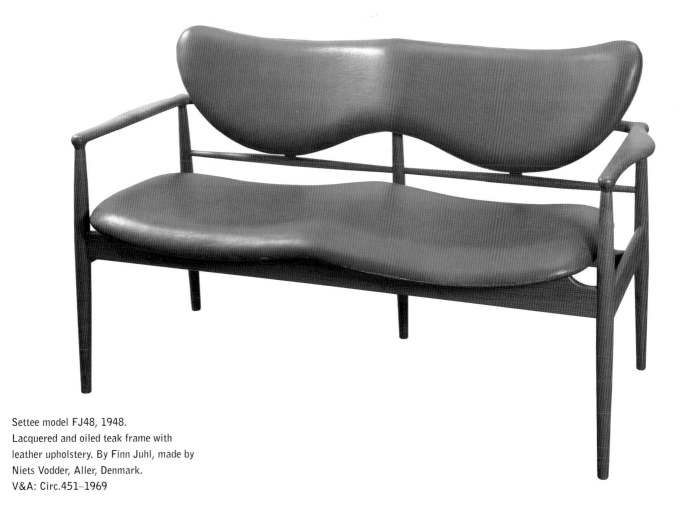

Settee model FJ48, 1948.
Lacquered and oiled teak frame with leather upholstery. By Finn Juhl, made by Niets Vodder, Aller, Denmark.
V&A: Circ.451–1969

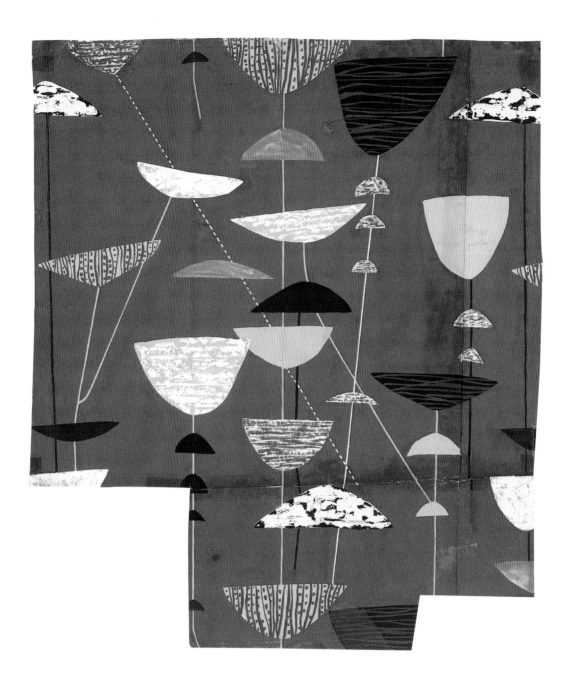

Design for 'Calyx' textile, 1951

Lucienne Day (b.1917)
Watercolour, gouache and collage
V&A: Circ.285–1955

Opposite: 'Calyx' textile, 1951.
Screen-printed linen.
V&A: Circ.190–1954

Lucienne Day's repeat pattern of spindly-stemmed calyxes (the covering of a bud), was greatly influential in the new abstract, busily decorated furnishing fabrics of the 1950s, and virtually changed the whole concept of textile design around the world. In a muted olive ground dotted with red and yellow abstract forms, the design is a collage made up of different painted pieces stuck onto paper. Produced by Heal

Fabrics Ltd., it was featured on their stand at the Festival of Britain exhibition in 1951. At first Heal's were not convinced that this innovative style would be successful, but it went on to win a gold medal at the Ninth Triennale in Milan in 1951 and in the same year received the International Award of the Museum of Modern Art, New York, for the best textile of the year.

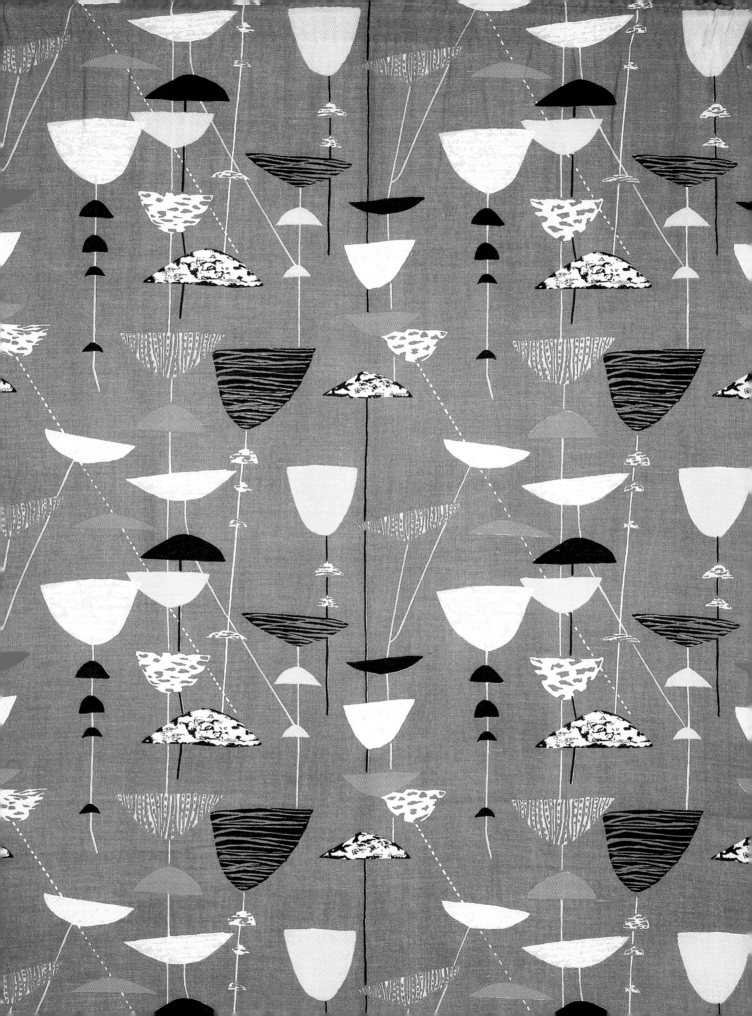

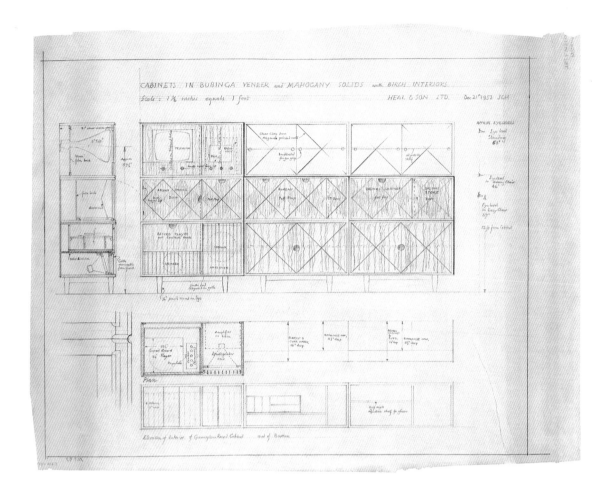

Design for unit living-room furniture, 1953

J. Christopher Heal (1911–85)
for Heal & Son Ltd.
Pencil on tracing paper
V&A: E.686–1978

As soon as the Utility Scheme restrictions were lifted in January 1953, there was a demand for highly designed furniture with rich finishes. The shop and manufacturer Heal & Son Ltd. (Heal's) had, in pre-war years, tended towards the more minimalist forms of International Modernism and chose to stay with the simple, reserved forms as seen here in the rectilinear look of these wall cabinets. Here there was, however, no constraint in the use of

expensive materials and, as can be read on the sheet, these units were intended to be made in bubinga veneer and mahogany solids with birch interiors. They are also particularly interesting pieces of living-room furniture, as they have housing for the latest in-home entertainment, including a television, record player and radio with the speakers in the bottom cupboards, bookcases (each with sliding glass doors), a bureau unit and a cocktail cabinet. Since the first viewing licences had been issued in 1933, televisions had been an expensive commodity for most people, and it wasn't until the coronation of Queen Elizabeth II in 1952 that many homes acquired a set. From this point onwards they were increasingly common objects in every home,

and became the main focal point of the living room for the rest of the 20th century. Unlike listening to the radio, viewers had to gather round more closely, usually not far from the fireplace (the traditional focal point of the living room), which resulted in a more clustered seating arrangement. This television cabinet is designed so that at a distance of 12 feet (3.6m – the recommended distance for watching television), viewing was, according to the notes on the design, 'Excellent in Easy Chair'. Presumably the effect of looking up to the television was based on the cinema experience. This 'Unit Furniture' was advertised in Heal's 1955 catalogue *Living Room Furniture*, and was available in either separate units or the complete wall unit.

Revised versions of the original working drawings for the Eames Lounge Chair and Ottoman, 1955 and 1972

Charles (1907–78) and Ray Eames (1912–88)
Dye-line print
V&A: E.615–1980

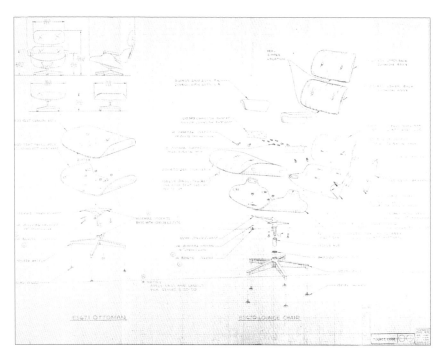

This is a 1970's dye-line copy of an original exploded specification drawing by Charles and Ray Eames, which has had later modifications made to it. Exploded specifications are useful to designers and manufacturers for clearly showing all the separate components and how they relate to each other. Charles Eames first came to prominence as a chair designer

in 1940 when, with Eero Saarinen (1910–61), he won the 1940 'Organic Design in Home Furnishings' competition at the Museum of Modern Art, New York. In 1942 Eames and Saarinen worked for the US Navy developing plywood leg splints. From this work he experimented further with moulded plywood and steel in furniture design and, working with his wife Ray from the late 1940s, developed the pedestal Eames

Lounge Chair in 1955. The new point about the Eames plywood technique was that the plywood was moulded into curves of more than one plane. This model proved to be so successful that it is still in production and has achieved 'classic' status around the world.

Eames Lounge Chair and Ottoman, 1955. Laminated rosewood on steel base with down- and foam-filled upholstery. Manufactured by Hermann Miller Inc., USA from 1956 and Herman Miller Great Britain from 1970.
V&A: Circ.67&68–1969

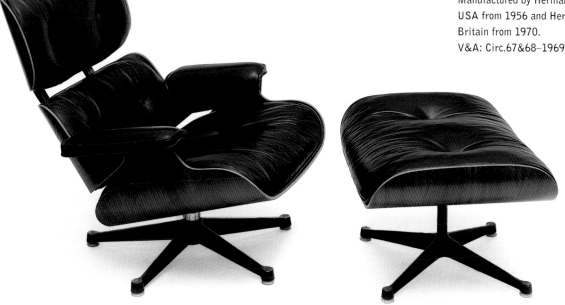

18 (below)

Artist's impression of a sitting room furnished with 'G-Plan' furniture, 1960

Leslie Dandy (b.1923)

Pen and ink and watercolour

V&A: E.335–1978

The 'G-Plan' furniture range, designed by Leslie Dandy and manufactured by E. Gomme & Sons Ltd., High Wycombe, was one of the first attempts in Britain to establish a readily available post-war style. As can be seen in the 'G-Plan' bed-sit (plate 81), Dandy developed the simple, modern forms of Utility into a more comfortable and stylish range of well-made furniture. By the early

1960s, however, the influence of American styling can be seen in this design for a setting for a 'G-Plan' settee and easy chair, which was probably rendered by a member of Dandy's design studio. It gives a light and lively impression of how a room could look containing this new, sleek-lined furniture. The glass and chrome coffee table, which was a new development in popular living-room furnishing, reflects the bright light from the window, as does the material on the suite, and the tall plant in the centre looks healthy with glossy leaves adding to the positive feeling of the room.

The finished articles, as seen in black and white in the accompanying marketing leaflet above, do not quite live up to the bright and cheerful

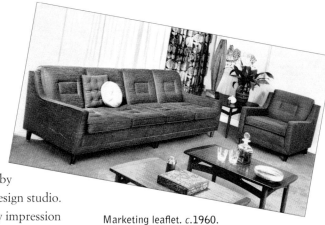

Marketing leaflet. c.1960.
V&A: E.335A–1978

picture of the artist who carried out the drawing. The settee and easy chair suite look very similar to the original design, although the arm-chair has lost its wide arms. Obviously a major selling point, the leaflet states that 'Streamlined American styling gives this group distinctive and luxurious good looks. Its cushions of latex and terylene fleece give extra soft comfort'.

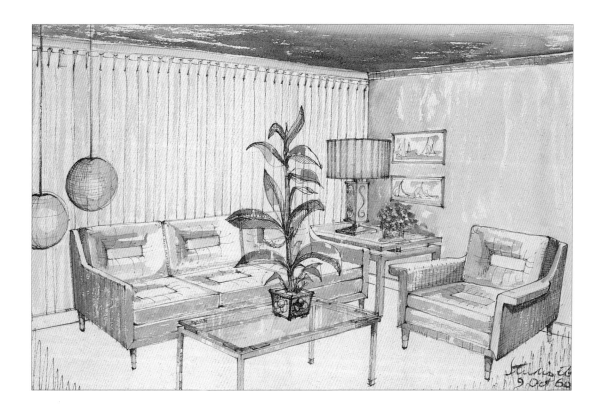

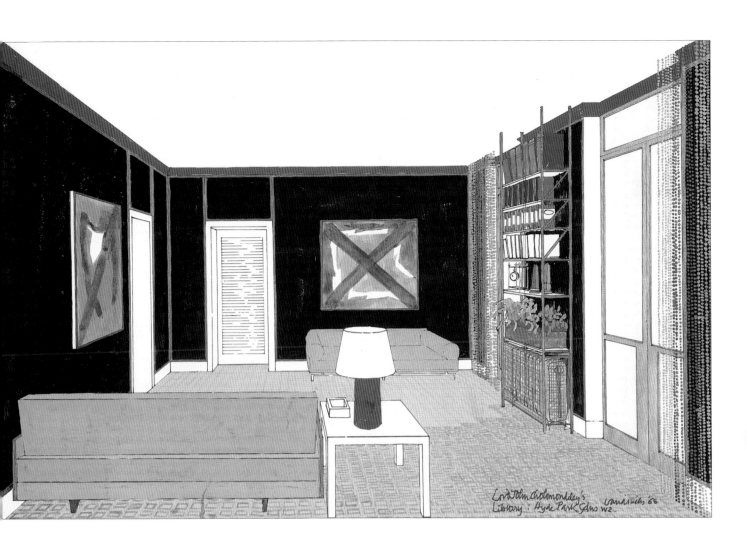

Lord John Cholmondeley's Library: Hyde Park Gdns W2. David Hicks '66

19 Interior design for
 Lord Cholmondeley's
 Library, 1965

 David Hicks (1929–98)
 Pen and ink, coloured pencil, water
 and bodycolour
 V&A: AAD/4/1986

Designing interiors and textiles from the 1950s, David Hicks specialised in creating modern looks through using bold colours, furniture grouping and mixing the best of the old and the best of the new. This design certainly shows this, with the striking juxtaposition of black walls with canary coloured furniture which was typical of 1960's interiors.

This design for a room in an existing house is much more sparse than traditionally decorated libraries, and is furnished with two diametrically opposed long, oblong settees, including one by the British designer Robin Day (b.1915). The library has simple, straight lines and a spacious, uncluttered feel to it, and the decorative effect is brought about by Hicks's feeling for contrast and strong colours. The old traditional radiator is cleverly hidden, incorporated into the spindly, free-standing shelf unit, while the new bead curtains, very popular in the late 1960s and early 1970s, give a lighter feel to the space than normal textile draperies.

... the striking juxtaposition of black walls with canary coloured furniture which was typical of 1960's interiors.

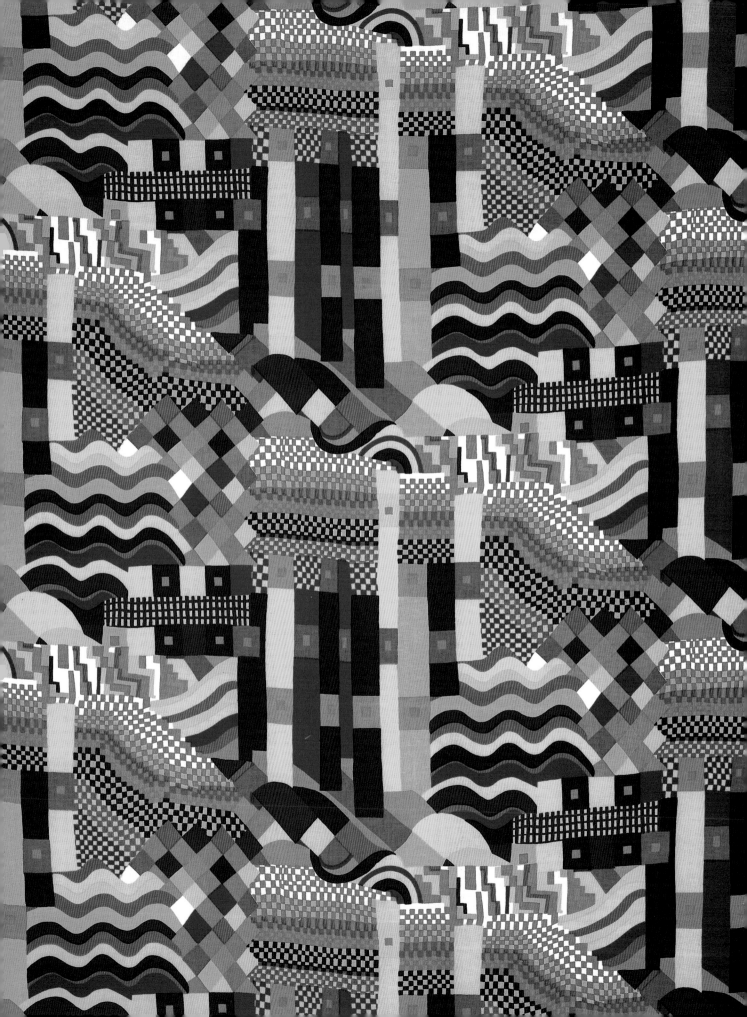

Design for 'Bauhaus' textile, 1969–70

Susan Collier (b.1939) and Sarah Campbell (b.1945)
Pencil and bodycolour, squared in pencil
V&A: E.258–1984

This design for a furnishing fabric for Liberty & Co., London was inspired by a slit tapestry entitled '5 Chöre' (5 Choirs) by Gunta Stölzl, working at the Bauhaus in the 1920s and 1930s. The original tapestry, one of the designs for which is shown below, was an exercise in creating simple, spatial planes through form and colour. During the late 1960s there was a general reassessment and interest in the work of the Bauhaus Workshops. Susan Collier and Sarah Campbell were particularly interested in the vivacity that the Bauhaus brought to their textiles through their use of bright colour and abstract forms. As a homage to the Bauhaus they adapted the tapestry, which they saw in a catalogue in the late 1960s, into a repeat pattern for a printed fabric. The rich optical impression of the design itself maintains its life force as a fabric on a roll. The designers wanted to keep the shape of the hand-painted lines and forms of the design in the finished product. This was innovative at the time as printers had been in the habit of straightening 'wobbly' lines, making the printing

process easier. The use of squares in furnishing fabric was also new in the early 1970s, but became popular in the scarf version first produced for Liberty & Co. in 1969, and later in the woollen dress and cotton furnishing fabric that followed. Used extensively to cover suites, curtains and tablecloths, it is still in production. The technique of drawing textile designs on squared paper, known as 'squared-up for transfer', was the designers' method of giving accurate dimensions per square inch for the manufacturer.

Below: Tapestry design, 1927. Pencil, watercolour and gouache. By Gunta Stölzl (1897–1983).
V&A: Circ.708–1967

Left: 'Bauhaus' furnishing fabric, 1972. Printed cotton.
V&A: T.447–1977

21

Design for a living room for the *Daily Telegraph Magazine,* 1968

Designed by Max Clendinning (b.1930), drawn by Ralph Adron (b.1937)
Poster-colour and collage
V&A: E.825–1979

This eye-catching design was made for the first of a series of five articles published in the *Daily Telegraph Magazine* in 1968, entitled 'Take A Room: One room, five ideas'. The designer's brief was to take an existing room and turn it into something modern and comfortable and economical to implement. Clendinning started by removing the fireplace and creating a deep moulding in the ceiling with spotlights. The same year as Raymond Loewy's designs for NASA (fig.10), Clendinning's living room has an overt space-age feel to it. Aimed at the 'alternative lifestyles' of the young of the late 1960s, this platformed,

contoured living room in bright yellow was arranged with convenient service modules. The pyramidal module 'service station' in the centre is made up of carpeted boxes and contains a built-in television, a record player complete with a rack for records and an electric coffee maker. The layout in this living room is convenience and lifestyle-led. The electrical appliances and the telephone are conveniently situated in the same room and near to the sitting areas, rather than at the periphery of the space as dictated by wall-mounted sockets, or elsewhere in traditionally designated separate

rooms such as the kitchen or hall. The bucket-like seating and foam scatter cushions are from Clendinning's own 'Meniscus' range of chairs and provide a choice of areas around the room to sit in. He chose yellow for the living room because he found it eliminated the feeling of clutter and, together with his preference for contoured lines, gave the space a continuous, flowing feel. Ralph Adron's rendering technique manages to combine indications of the ceiling and ground plan with his almost two-dimensional, highly influential technique. The ideas behind Clendinning's living area were a precursor to John Prizeman's 1972 'Add-On Cooking Post' (plate 47), where as many services as possible were reduced to one convenient, space-saving module.

Tubular chairs in domestic setting, 1977

Drawn by G.P. Wood for Conran Associates, designed for Dual Furniture
Felt-tip pen and watercolour
V&A: E.1129–1979

This rendering is a presentation drawing showing the 'Viking' range of furniture in a domestic setting. The range of hi-tech tubular metal furniture, painted in bright 1970's colours, represented a complete departure from the traditional cosiness of British furnishings. The industrial look of the seating and tables fitted into the new mid-1970's fashion for converting industrial premises and warehouses into living spaces, where the old boundaries between domestic and work space were being blurred. Like much of Conran's furniture, this range was intended equally for domestic or business use.

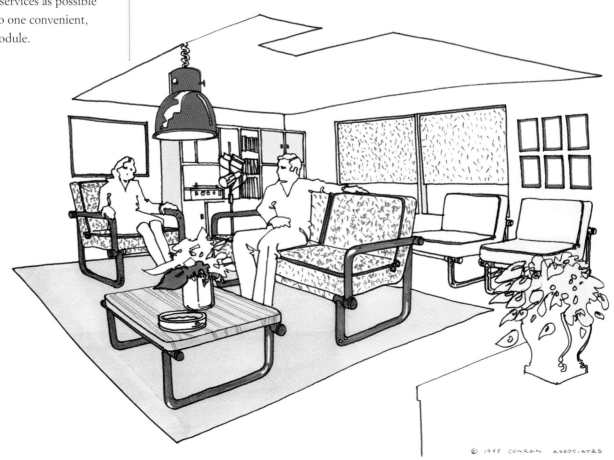

© 1977 CONRAN ASSOCIATES

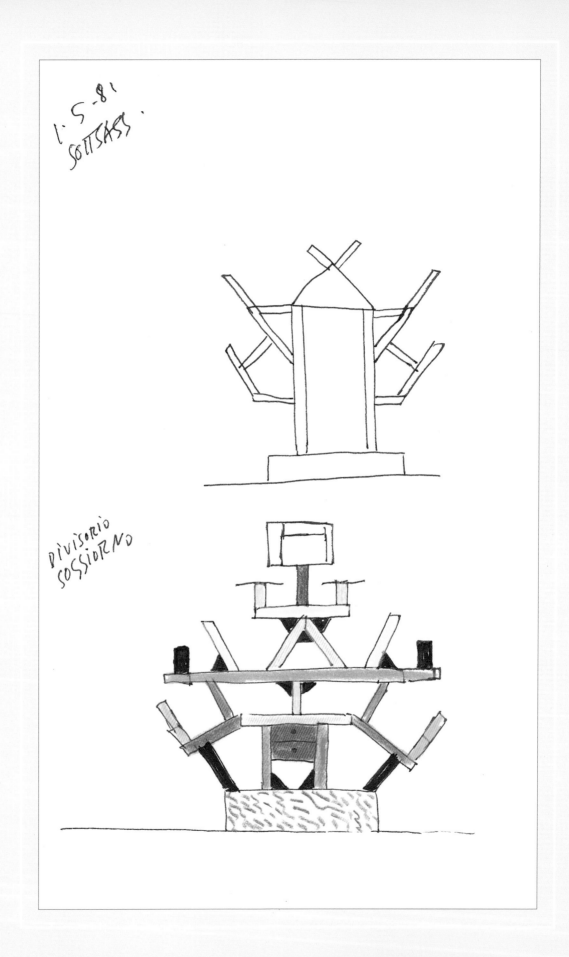

Designs for 'Carlton' bookcase and 'Casablanca' sideboard, 1981

Ettore Sottsass Jr (b.1917)
Pen and ink, coloured chalk,
bodycolour
V&A: E.414–1986

These designs are for functional pieces of furniture, although they flout any traditional expectations and preconceptions of how a set of shelves should look and work. The 'Carlton' has the character of a playful anthropomorphic being, like a stickman or insect, as intended by the designer. There are very few vertical or horizontal supports, and with the short slanting dividers and the rainbow of bright candy colours it has an almost childlike quality. Both designs have a speckled effect on the base (seen here in the finished 'Casablanca'), a surface decoration technique derived from patterns used for plastic laminates from the 1950s and which was used extensively by the Memphis group. These pieces of furniture clearly show how Ettore Sottsass, in a conscious bid to create objects using 'non-cultural imagery', drew on a wide range of cultural references not previously associated with design. He founded the Memphis design group in Milan in 1981 to explore the potential impact of a richer visual design language. The group's aim was to produce everyday objects but with a high aesthetic quality, created through the application of bright colours and decoration onto imaginative forms. Memphis wanted to challenge the relationship between manufacturers and customers where the makers were led by consumer demand for standardised commodities, which was the culmination of mass-machine production for mass markets.

This radical anti-design approach challenged homogenised Italian high-style design which, based in Milan, had evolved out of a tradition of elegant, flattering forms with rich traditional materials.

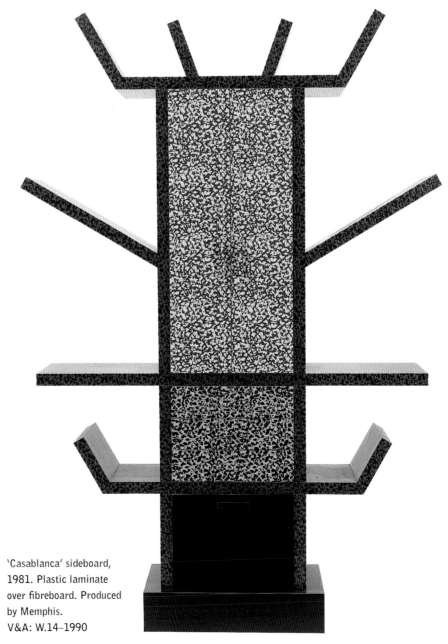

'Casablanca' sideboard, 1981. Plastic laminate over fibreboard. Produced by Memphis.
V&A: W.14–1990

Design sketch for 'Art Nouveau' chair, 1982

Robert Venturi (b.1925) for Knoll International
Felt-tip on yellow paper
V&A: E.317–1986

Robert Venturi came out of the same anti-design strand as Ettore Sottsass, but was more interested in the heritage-inspired rhetoric of Post-modernism. Taking forms and images from previous historical styles, he remodelled and recontextualised them in his buildings and furniture. In this early drawing, the elongated, elegant form of Art Nouveau is featured in the tall back. The chair was one of a group of nine chairs, two tables, a low table and a sofa that Venturi designed for Knoll in 1984. The details in the shape of each piece refer to a particular period style, but the same basic form of the carcass is retained across the set. Seen below is the finished 'Chippendale' chair, where the typical mid-18th-century style is used in the back of the chair. It could be argued that this was part of the continuous thread of traditionalism in design throughout the century, rather than an innovative style.

The range also challenges traditional preconceptions of suitable materials used to make furniture: made in a thin plastic laminate and decorated in the 'Grandmother' pattern, which was current throughout the range, the chair doesn't look substantial enough for its purpose.

'Chippendale' chair, 1984. Laminated plywood with plastic laminate surface. Manufactured by Knoll International. V&A: W.21–1990

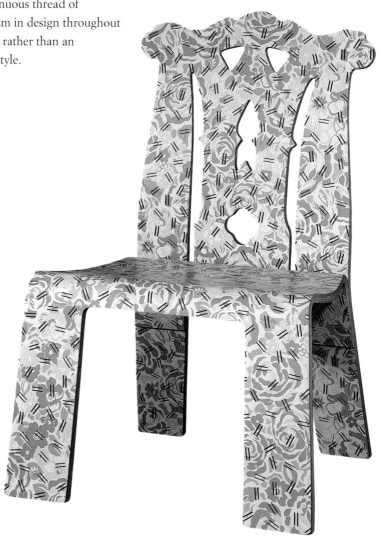

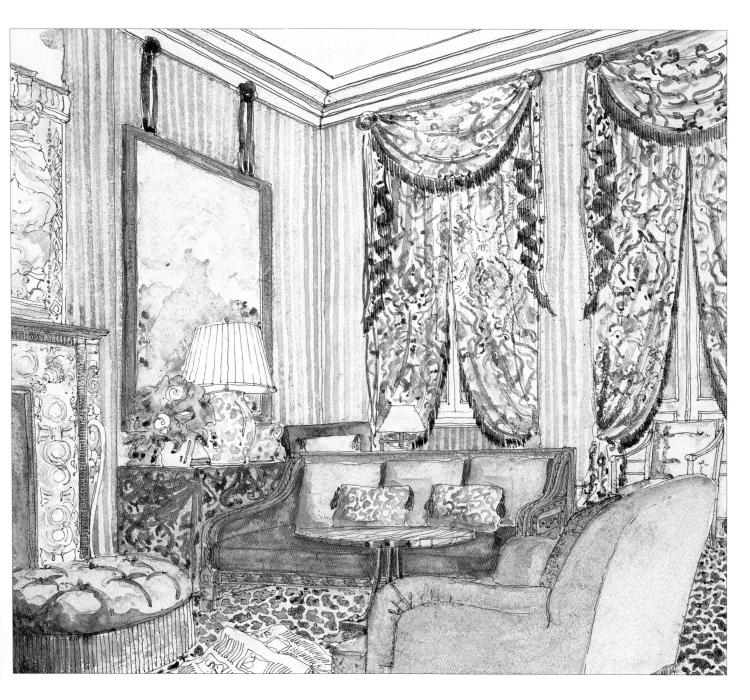

25

Design for a drawing room, 1986

John Stefanidis, drawn by Philip Hooper
Pencil, pen and ink on printed tracing paper
V&A: E.200–1986

This design for a drawing room is typical of John Stefanidis's use of bright colours in the mid-1980s. Rendered by Philip Hooper of the designer's studio, the elaborate ceramic chimneypiece is the starting point for this opulent, comfortable drawing room filled with choice pieces of gilded antique furniture.

Here, he introduced a new treatment to the otherwise traditional historical furnishings in the room, using the pattern-on-pattern effect and creating a riot of stripes, swirls, tassels and animal markings. The varied end result is enlivened by the busy mix of many shades of pink and the tactile textural qualities.

Designs for 'Pylon' chair, 1992

Tom Dixon (b.1959)
Colour laser printout
V&A: E.454–1999

This is an early example of a two-dimensional CAD (Computer Aided Design) printout, which was not generally used by furniture and product designers until the late 1990s. The benefits of working out three-dimensional objects on screen, however, were quickly appreciated and soon led to the wide use of three-dimensional CAD. From the early 1980s, Tom Dixon had been working with scrap metal in an *ad hoc* manner, welding 'ready-made' objects into furniture which had overtones of the Post-industrial look. The 'Pylon' chair challenges preconceptions of furniture materials and structure, making overt references to industrial engineering, and is an example of unusual, high-designed furniture.

Pylon chair
do not scale
2.4mm steel wire

Working sketches for 'Table = Chest', 1995

Tomoko Azumi for Azumi
Pencil and watercolour
V&A: E.457–1999

Multi-functional flexible furniture was the key to the 1990's interior. As living spaces got smaller, the pressure on furniture to have more than one function and to justify its very existence were the issues that were challenging designers. In solving this problem, Tomoko Azumi wanted to design furniture that would make home-living easier and enjoyable. These preliminary sketches for 'Table = Chest', taken from Azumi's sketchbook in her final year of Furniture Design at the Royal College of Art, London, show how she developed the idea that the piece would involve some sort of movement which transformed its function and form. The design demands that people physically interact with the shift in the shape of furniture, and that by doing so their behaviour is directly influenced by the furniture. It is like a piece of live theatre with audience participation. The neat fittings and shape of 'Table = Chest' are obviously influenced by Tomoko Azumi's Japanese roots, while the thin splayed legs also draw on a much more contemporary version of 1930's International Modernism. The fine details, such as the hinges, were all thought out at an early stage and brought up with the rest of the design as an organic whole. The result is neat and elegant, whilst also being very practical. As a piece of furniture it could easily fit into any space in the home.

'Table = Chest', 1995. Beech veneered MDF, beech-wood and metal fittings. V&A: W.6–1997

Design for the Vaight loft conversion, _c_.1994

Circus Architects
Photocopy of a drawing
V&A: E.630–1999

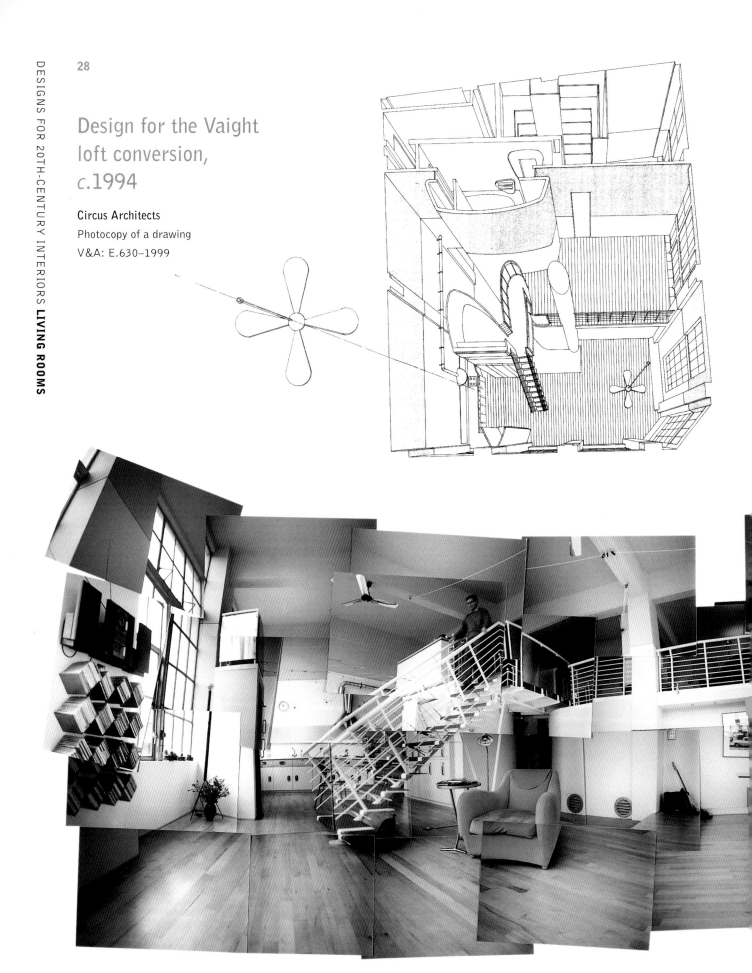

This one-point perspective drawing (left) for a residential loft conversion in Shoreditch, London, demonstrates the new possibilities of layout and organisation that were brought about with loft spaces in the 1990s. Different sized units require different treatments, but this example, completed in 1995, shows the average ideal loft conversion. The main living space at the front of the drawing has a double-height ceiling and is the full width of the loft space, with the kitchen at one end and a dining area at the other. The entrance is from the mezzanine level, on which there are open multi-functional areas around the balconies. Bedrooms are on both the mezzanine floor towards the rear and on the lower floor (so that they meet the building regulations stipulation that bedrooms have a window opening to the outside). There are also bathrooms on both levels. The International Modernist style has been introduced into the balustrade and staircase with its rectilinear bars, typical of 1930's ocean-liners. The design also shows the 1990's desire for greater privacy, with the bedrooms and bathrooms made into more conventional walled-off rooms. Living activities were not fixed in one designated area (apart from cooking) and could be moved to any part of the open space for convenience. The living space also includes the cooking and eating activities, emphasising the amalgamation of these functions. The occupant of the loft chose to relax sitting in the armchair (by Matthew Hilton, b.1958), positioned away from any walls with nothing close by except a standard lamp, and with the full advantage of the unrestricted view from the large, full-height windows. This reflects the loft-dweller's desire for emptiness, space and light, which are rarely available in the conventional town house or urban flat. With the original factory windows, traditional form of air circulation and the introduction of the large, industrial-looking steel extractor above the oven (very important to avoid the spread of cooking smells into the rest of the space), this loft highlights its industrial heritage.

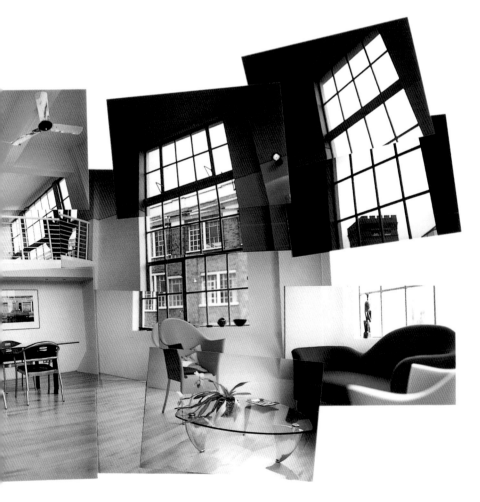

Photomontage of the Vaight loft conversion, 1995. Circus Architects

Kitchens and Dining Rooms

The domestic kitchen was the centre of much attention during the 20th century and its appearance and use changed radically during that time. New technologies and changing lifestyles greatly altered the cooking and eating landscape in the middle-class home, resulting in more flexibility in kitchen and dining-room layouts. Preparing food, cooking and eating became less compartmentalised, and eating became less formal, moving away from social rules binding it to designated rooms. From formal dining arrangements, with servants (most middle-class households had at least one) carrying food between the kitchen and the dining room (not always conveniently located next to each other), to TV-dinners on laps, the culture of food consumption changed dramatically.

At the turn of the century, middle-class homes in Britain had a maze of small rooms all contributing to cooking and eating: pantries for storing cooking utensils, cool larders for food and sculleries with a sink for the washing-up. This was before one reached the kitchen. Each room was furnished with pieces of furniture, which were usually acquired over time, apart from very well-off households which often had custom-made fitted cupboards. The ideal kitchen, as published by Mrs Waldemar Leverton in *Small Homes and How to Furnish Them* (1903), contained a dresser, an assortment of cupboards sitting on the floor around the walls, and a central wooden table forming the main preparation surface as well as the eating place for domestic staff. The wooden surfaces, which required a weekly scrub-down with scalding water and bleach, were highly labour-intensive to keep clean and hygienic. There was also the cooking grate which, of course, needed the ashes cleaning out and a continual supply of coal or chopped wood. With the later introduction of gas and electricity supplies, the position of the cooker did not have to be dictated by an architectural fixture (i.e. the chimney).

Maintaining this sort of kitchen arrangement was manageable with the help of servants, but after the First World War the availability and affordability of domestic staff declined. This usually left the lady of the house to do everything on her own. Many women complained of exhaustion, which was partly due to all the walking between the many kitchen-associated rooms. This prompted a reassessment of the efficiency of the kitchen, resulting in the reduction of the number of rooms and the kitchen itself becoming smaller and more multi-functional. This problem had already begun to be addressed in America at the end of the 19th century by women campaigners such as

Charlotte Beecher and Christine Frederick. Advocates of improved kitchen conditions, their ideas were spread through publications such as Christine Frederick's *Scientific Management in the Home* (1915). Their ideas were also taken up across Europe.

The Americans took the approach that the kitchen should be run as efficiently as an industrial production line, and indeed the end result looked like the product of a machine-age aesthetic, filled with metal tools and gadgets to aid in meal making. However, it wasn't until the ideas of efficiency in the kitchen reached Europe that the new kitchen began to take on its own aesthetic and look more like a room in a home than a factory.

The German women's movement was equally concerned with better planned and more efficient kitchens, and after 1922 was given considerable impetus by the translation into German of Christine Frederick's ideas. By 1924, Grete Schütte-Lihotzky, in an attempt to provide an ergonomic solution for a labour-saving kitchen in mass housing, designed the 'Frankfurt Kitchen'. The result of detailed studies of the way in which work was carried out in kitchens, it had built-in cupboards, storage units and work-surfaces. It was also greatly influenced by similar work being done simultaneously at the Bauhaus, and so the aspects of practicality were joined with attempts to make it attractive in a modernist idiom. The concept was seen, however, as being very much associated with socialist movements at a time in which women were challenging their domestic role. The wish to transform the kitchen into an efficient workplace was a conscious effort to give housework an equal status as standards of work in the professional, male-dominated market, which many men saw as a threat. It was also often linked to general improvements in mass social housing, which for many had negative connotations of extreme left-wing socialist movements. These and the cold, hard appearance of the Modern Movement kitchen may explain why it was not embraced in Britain before the Second World War. But the female force was effective and very soon manufacturers began to address the problem.

During the 1920s and 1930s there was a proliferation in the advertising of kitchen gadgets, which were more widely taken up by the American market than by British household goods consumers. The need for hygienic, efficient and attractive kitchens required designers and architects to create the wonderful new looks. Many designers in Britain and America in the 1930s and 1940s were émigrés from European countries where the new forms and ideas

were being developed. However, designers held a greater status in America than in Britain, where they were not really acclaimed until the 1950s.

In America, the planning and designing of kitchens and kitchen aids continued unabated throughout the war years. By the early 1950s, America was well ahead of Britain where, due to material and economic restrictions, the designing of products for domestic consumption had all but stopped and many designers were engaged in war-related production. At the beginning of the 1950s the British market was like a huge sponge, waiting to soak up all the new and exciting products on offer from across the Atlantic. American marketing and sales executives were only too happy to fulfil the demand, and there was a huge influx of American cultural commodities which greatly influenced the furnishings and decorations in the British home. All the brightly coloured surface materials and shiny chrome appliances were welcomed into the austere backdrop of post-rationing Britain, and the domestic appliance market finally took off. Labour-saving kitchen aids, such as refrigerators, cookers, electrical appliances and dining tableware, which had first been developed in the 1930s, were taken up with great enthusiasm in the late 1950s and early 1960s. Suddenly they were all important for the post-war convenience- and image-conscious, modern housewife, who was increasingly exposed to the proliferation of advertisements for clothes and commodities. By this time, a greater number of women than ever before had time to read women's magazines, listen to the radio, watch television and go shopping, constituting a captive audience for marketing.

The British manufacturing industry responded to this challenge, and by the early 1960s had established inroads into the kitchen market, with companies such as Hygena and Kenwood becoming household names synonymous with well-made, modern-looking products. Space, however, was still an unresolved issue, and kitchen/diners or living-room/diners became necessary developments. The idea of eating and cooking in the same space became respectable, and dining in a separate room almost a thing of the past.

In the 1970s and 1980s, designers set about finding ways of fitting as many cupboards into the kitchen space as possible. Whether this comprised open-plan kitchen/diners, farmhouse or galley kitchens, bands of neatly fitted cupboards were wrapped around the walls from the floor to the ceiling. Ultimately all kitchen clutter and utilities could be shut away behind continuous cupboard doors, leaving long stretches of work-surface. In some cases,

general household ornaments decorated the kitchen, with the intention to remove its work-like appearance, and so created another living/reception room. During the late 1980s some kitchens began to take on the look and function of a living room, where the family relaxed and entertained visitors.

The 1990s saw a backlash against cupboard fetishisation and a move towards storing food supplies and kitchen utensils on simple, open, free-standing shelves. Exposing your food stores and utensils for the world to see, as in an Italian or French farmhouse kitchen, became the thing to do. This move away from the meticulously designed environment was ironically the culmination of Terence Conran's 'Continentalisation' influence in the late 1960s, and was informed by the popular practice in the 1980s and early 1990s of taking holidays in rustic farmhouses and villas in Continental Europe. The trend affected 'white goods' – utilities such as fridges, washing machines and dishwashers which had become standardised to fit under work surfaces. Once again, they became stand-apart furniture, cutting down the work-surface which began to be made in natural products such as slate and wood. At the top end of the market, goods such as fridges began to appear as free-standing elements in different shapes and striking colours, with the obvious intention of asserting individuality. This also had something to do with the early 1990's retro interest in 1950's American mass-produced commodities. More of a cult than a revival, it centred around objects which embodied the prosperity and freedom seen to be present in 1950's America, achieved through mass-production with machine-age styling. In 1999 ideas were moving in the direction of fitting products, such as washing machines and tumble-dryers, straight into walls at a convenient work height so that they took up no room at all. These microchip-run machines could even be programmed to divide up the white and dark washes themselves.

This seems an ironic end to a century in which the kitchen became the central arena for battles over improvements in working practice, efficiency and hygiene in cooking and eating spaces. But then the making of food in the 1990s, much of which was ready-prepared before reaching the kitchen, was a very different scene from the housewife's constant struggle to feed the family earlier in the century. While this does not signal the immediate demise of the white goods market in kitchen products, it does suggest how people would prefer to plan their ideal cooking and eating activities and the spaces in which they happen.

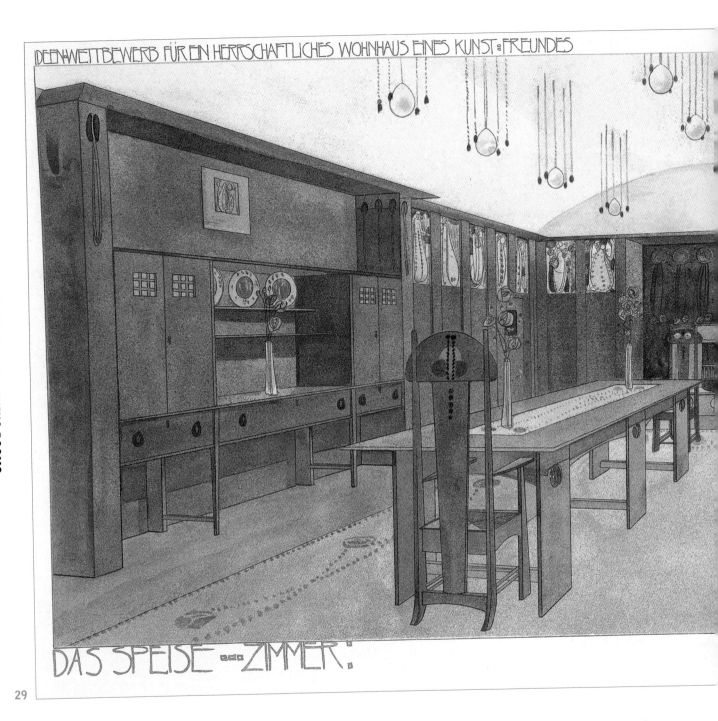

IDEEN·WETTBEWERB·FÜR·EIN·HERRSCHAFTLICHES·WOHNHAUS·EINES·KUNST·FREUNDES

DAS SPEISE ·· ZIMMER·

29

Dining room in the 'House of an Art Lover', 1901

Charles Rennie Mackintosh (1868–1928)

Published in *Haus Eines Kunst-Freundes*, from the series *Meister der Innen-Kunst* (1901, vol. II, pl.xiv)
V&A: L.794–1902

This dining room was designed in 1901 by Charles Rennie Mackintosh, who was a key member of the Glasgow School. Mackintosh and other masters of architecture and design in Europe, such as Hugh Mackay Baillie Scott (see plate 56), were invited by the German architect Hermann Muthesius (1861–1927) to partake in a competition to design rooms for an ideal 'House of an Art

Lover'. Mackintosh took second prize, and the entries were published in large volumes in the series *Meister der Innen-Kunst* (Masters of Interior Art). Mackintosh's 'Dining Room for an Art Lover' contains many of the forms characteristic of his style. There is an emphasis on exaggerated verticals, especially in the high-backed chairs, wall panelling and the delicate suspensions of the ceiling

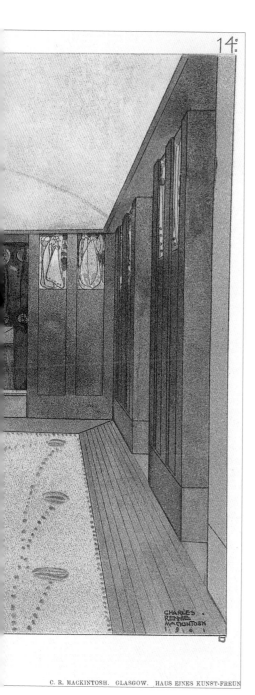

C. R. MACKINTOSH. GLASGOW. HAUS EINES KUNST-FREUN

English and Arts and Crafts, and suitable for the contemplation of an art lover. Although this design is a flight of fancy for Mackintosh, he did make up one of the stained-glass panels from this room to give to Muthesius's son, his godson, in 1903–04, which is now in the Museum für Kunst und Gewerbe, Hamburg.

The plate design (below) is similar to those displayed on the shelves on the left-hand side of the 'Art Lover's Dining Room', and was probably for a decorative, rather than a practical purpose. It is unfinished, revealing Mackintosh's design technique: the circular plan is in pencil with a light wash used for shading and a radial line, hatching marks to indicate the 'dip' in the centre of the plate and finally watercolour for the decoration. The pattern radiates from and echoes the wavy form of the clover in the centre point, which is contained in a quatrefoil. Around the rim, however, is a frieze of the small neat squares typical of Mackintosh's work.

Below: Plate decoration, *c.*1900–10. Pencil, watercolour and bodycolour. By Charles Rennie Mackintosh. V&A: E.863–1968

lamps. These are softened, however, by the more curvaceous Art Nouveau floral patterns in the stained glass, the fireplace decoration, on the buffet and the carpet design. The chairs are very similar to some he designed for his own dining room in 1900. The overall effect in this dark pastel-coloured dining room, with the long, dark, wood table stretching away, is a harmonious mix of Old

DINING ROOM · ELEV.
LOOKING TOWARD FIREPLACE
AND PLAN OF DINING TABLE

30

Design for the furnishings of the dining room of the C. Thaxter Shaw House, Montreal, c.1906

Attributed to Marion Mahoney (1871–1961), studio of Frank Lloyd Wright (1867/68–1959)

Pen and brown ink over traces of pencil
V&A: E.12–1982

In 1932, Frank Lloyd Wright wrote that, 'human beings must group, sit or recline, confound them – and they must dine, but dining is much easier to manage and always a great artistic opportunity'. Wright paid much attention to detail on the dining arrangements in all his houses. This drawing, showing the elevation 'looking towards the fireplace' and plan of the dining-table furnishings, distinctly shows Wright's perpendicular linear style of the first decade of the century. It reflects an Arts and Crafts influence as well as a concern for integrating the interior elements in a rational form. Unlike Mackintosh's contemporary linearity, there are almost no curves in the forms of Wright's clipped boxy style. Greatly influenced by Japanese architecture and interior planning,

by the early 1900s Wright's dining rooms had lost their walls and had become dining areas incorporated into larger open-plan living spaces. The chairs, however, with their tall slat backs arranged around the table form an enclosure in themselves and the dining table becomes a room within a room, as can be seen in the plan of the dining table here.

Marion Mahoney was one of Wright's principal drawing assistants between 1895 and 1909. This drawing shows her neat rendering style, clearly delineating natural decorative forms with architectonic elements, and includes Wright's distinctive stained-glass panels with their arrow-shaft pattern.

Design for a teapot or coffee pot, *c.*1910

Attributed to Fedor Ruckert (active first two decades of 20th century)
Pencil, watercolour and metallic pigment heightened with white
V&A: E.1654–1989

This presentation drawing for a cloisonné enamel pot was probably drawn by Fedor Ruckert for the firm of Carl Peter Fabergé. The work master of Fabergé's enamelling workshop in Moscow, Ruckert was known for his skill in cloisonné enamelling, a technique which was unique to the Moscow workshop.

The shape of the pot is not unlike a Fabergé egg which has sprouted a handle and spout and, like the famous eggs, the ornate decoration of the teapot makes it an ornamental piece rather than a practical object. The busy intricate pattern of a mixture of floral and geometric forms is derived from the Old Russian style, which had its beginnings in the 17th century. Enjoying a revival at the end of the 19th and early 20th centuries, this style was linked to Russian Nationalism and suited Fabergé's more traditional customers. Ruckert's designs with unusually muted colours had a modern touch to them and some had suggestions of more Art Nouveau influenced forms.

The inscription at the bottom – '*R(oubles) 250*' – is probably the going price for the finished piece.

Design for a condiment set, *c.*1905–10

Archibald Knox (1864–1933)
Pencil
V&A: E.348–1969

Of Scottish and Manx origin, Archibald Knox first designed silverware for the shop of Liberty & Co. in London, which included some of his designs in the influential 'Cymric' silver and jewellery range launched in 1899. His distinctive decorative Celtic forms contributed to the development of the Liberty house style known as 'Stile Liberty'. This design for a condiment set, comprising pepper pot, mustard pot, salt pot and spoon, indicates the types of tablewares used in the middle-class dining room in the first decade of the century. The leaf-like decoration on the spoon handle and pots, varied on each to show the alternatives available, would have been for coloured enamelling or semi-precious stones. The heart-shaped, pierced decoration for the top of the pepper pot is rather charming. As seen in plate 71, the heart was a popular decorative motif used by Arts and Crafts designers. These designs do not appear to have been produced by Liberty & Co. and may be presentation designs returned to Knox.

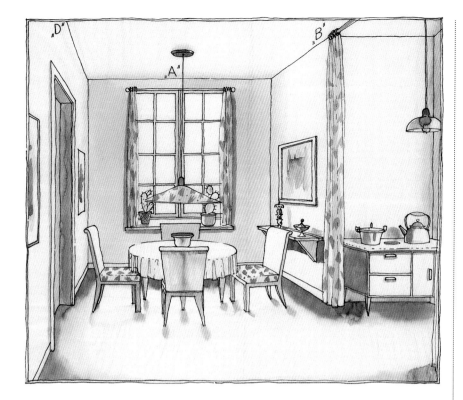

33

Design for a kitchen/diner, c.late 1920s

Berta Sander (1901–90)
Pen and ink wash on tracing paper
V&A: E.1392–1986

Berta Sander studied at the School of Arts and Crafts in Cologne, where she was taught by Philipp Häusler, who in turn had been a student of Josef Hoffman (1870–1956). One of the founding members of both the Vienna Secession and the Wiener Werkstätte, Hoffman was a key promoter of International Modernism in the 1920s. In 1923 Sander spent a year at the Wiener Werkstätte before returning to Cologne, where she set up a workshop as an interior designer specialising in wallpaper, furniture

design and single-person dwellings. It was during this period that she made this drawing. Sander was heavily influenced by architects and designers of the new International Modernist style in Germany, Austria and various Eastern European countries, who were concerned with developing a rational aesthetic for the new technologies. This design shows the separation of the kitchen from the eating area, which was key to new kitchen-planning in mass housing. Sander's obvious interest in flat pattern is seen in the dividing draperies and the matching patterns on the chair seats and lampshade. There is a strong Modernist influence in the furniture with its slim, tapered legs and the simple squareness of the forms, in the lack of decoration on the walls and floor, and in the choice of the crisp and spiky forms of the cacti on the windowsill.

Design for a kitchen, c.1934

Raymond McGrath (1903–77)
Pen and ink on tracing paper
V&A: Circ.548–1974

Raymond McGrath published this ideal design for 'Apparatus in the cooking-room' in his pro-Modernist book *20th Century Houses* (1934). An Australian architect working in Britain, McGrath was a major proponent of International Modernism in architecture and interiors in Britain. This was one of the first examples in Britain of a kitchen with an ordered assemblage of cupboards, oven and fridge, and is heavily influenced by the precedent model of the Frankfurt Kitchen designed by Schütte-Lihotzky ten years earlier. Every inch of wall space has been put to its best use. The lines are straight and neat, emphasised by the grid-like lines of the tiled floor – apart from the cabriole legs of the fridge, which are influenced by traditional 18th-century furniture and add a rather strange twist to the room. The fridge is the only piece of furniture that isn't fitted, as such, into the scheme, and the cupboard tops have not yet been given that single sweep of work-surface so important in later kitchens when the sizes of kitchen furniture become standardised.

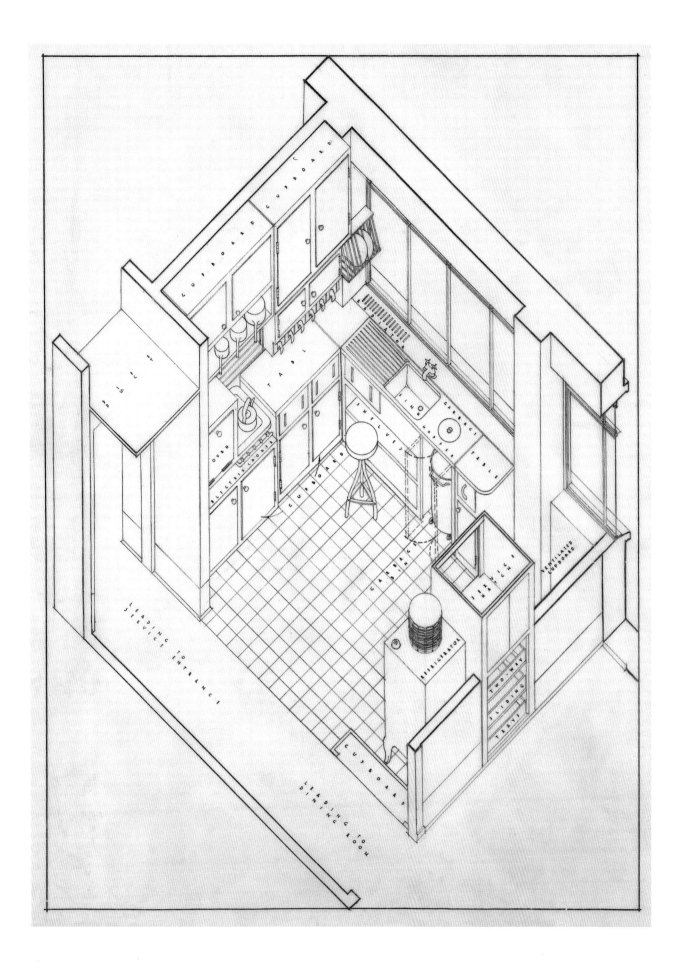

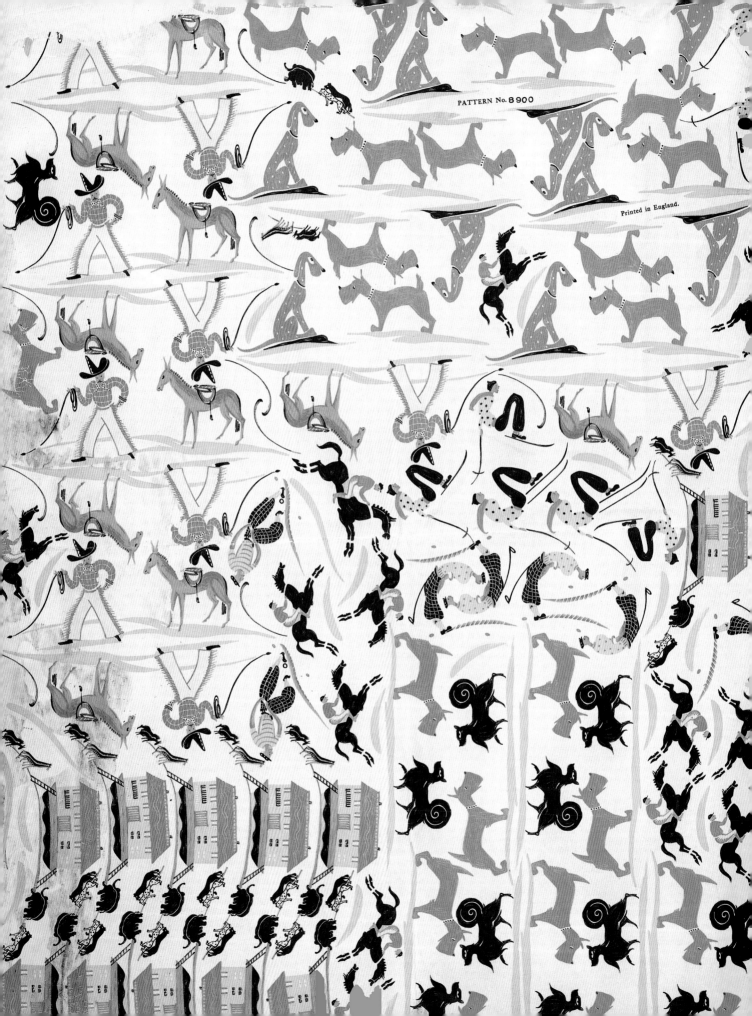

PATTERN No. 8900

Printed in England.

Noah's Ark transfer sheet (pattern no. 8900), c.1935.

Susie Cooper (1902–95),
of Susie Cooper Pottery

Colour lithograph

V&A: E.1593–1977

This sheet of lithograph transfers was for a special range of children's pottery designed by Susie Cooper and introduced around 1935. This colourful, lively, almost primitive form of International Modernism was very popular in the Susie Cooper trade show displays in 1936 and 1938. The simple forms were decorated with motifs of characters in exotic and exciting pursuits: a golfer on the tea-cup and saucer (as seen below), a horse and jockey side-plate, a skier swooshing down the side of a coffee pot and a Wild West cowboy in the bottom of a cereal bowl. These are technically interesting, as there were hand-made additions to the transfer: a green stroke with tufts for the grass and the coloured bands around the edge. Each transfer also included two small orange dots which were in fact markers for the worker to place the transfer onto the object accurately. Using lithograph transfers, which Susie Cooper insisted upon, was a costly technique and there was a need to keep the number of 'seconds' down to keep the price as low as possible – making the goods available to as wide a market as possible. Each transfer would have been cut out individually and applied to the crockery by a skilled professional. This was a crucial point in the

process as one slip could have ruined the whole piece at this late stage. The mix of motifs on the sheet shows that they would have been working on the range of different pieces at any one time.

The total effect is of something fresh and brightly hand-painted, but it is neat and consistent for the needs of mass production. The picture of Noah's Ark appeared on a slightly different range of nursery wares which could be ordered personalised with children's names.

Susie Cooper was undoubtedly one of the most influential designers of ceramic wares of the 20th century. A pioneer of International Modernism in Britain, she introduced new, often abstract and avant-garde designs as

well as more traditional styles, all of which had a wide appeal. The techniques that she developed over a career spanning more than seventy years were to shape the future direction of the ceramic tableware industry. After teaming up with Wedgwood in the 1960s, her new, fresh products were available to an even wider market.

Saucer from children's pottery range, c.1935. Earthenware with colour lithograph and hand-painted decoration. Susie Cooper Pottery.
V&A: Circ.438–1976

DESIGNS FOR 20TH-CENTURY INTERIORS **KITCHENS AND DINING ROOMS**

Design for a table, c.1936

Walter Gropius (1883–1969)
Pencil on tracing paper
V&A: E.2824–1995

As Director of the Bauhaus Workshops in Germany between 1919 and 1928, Walter Gropius was a key pioneer of the Modern movement. He came to Britain in 1934, and from 1935 was made controller of design for the Isokon Company in London, which specialised in plywood furniture and for whom this design was made. Although it is drawn by another member of the Isokon studio, the table design, complete with dimensions, has the approval of

Gropius's signature in the bottom corner. The design clearly shows the simple forms that Gropius promoted in his efforts to bring together art and technology in design. He taught that form should follow function but that products didn't necessarily have to lack aesthetic qualities. Even mass-produced objects could be beautiful, as well as well-designed, and he encouraged artists and designers to learn and work with each other. This type of table was used in small kitchen-diners or living rooms. There is no record of a table with these particular dimensions being made, although other similar models by Gropius were produced.

Design for a dining room, c.1936

Possibly by William Henry Russell (1907–73), for Gordon Russell Ltd
Pencil, watercolour and bodycolour, mounted onto black paper
V&A: E.311–1977

This design drawing of an axonometric view of a dining room shows the British form of Modernism produced by Gordon Russell Ltd. Showing a table, carving chair, two dining chairs and a sideboard, the stark and minimalist character was a sharp contrast to traditional revival styles that were most popular at this time. The table has been stripped of all embellishments, leaving a distinctively sharp-lined rectilinear piece; the chairs, too, have straight, slightly tapering legs. The rectilinear shapes of the drawers and cupboards in the sideboard are picked out through the contrasting wood veneers, which are the only form of surface pattern on the furniture. In contrast, the carpet, in subtle pale blues and yellow, is patterned with rows of gently undulating lines and spots, softening the harshness of the lines and dark tones of the furniture. Dining rooms still had an allocated space in most middle-class homes at this time. In Britain from the 1950s, however, with the trend in having one through room instead of a sitting room and a dining room, they were frequently used less.

... form should follow function ...

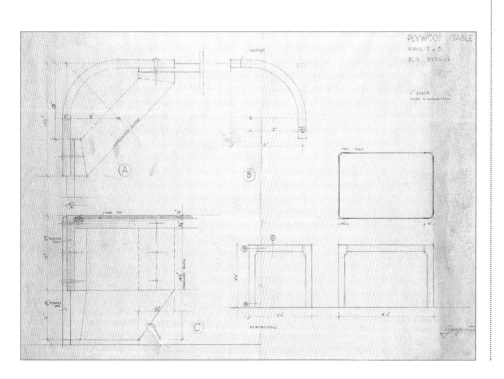

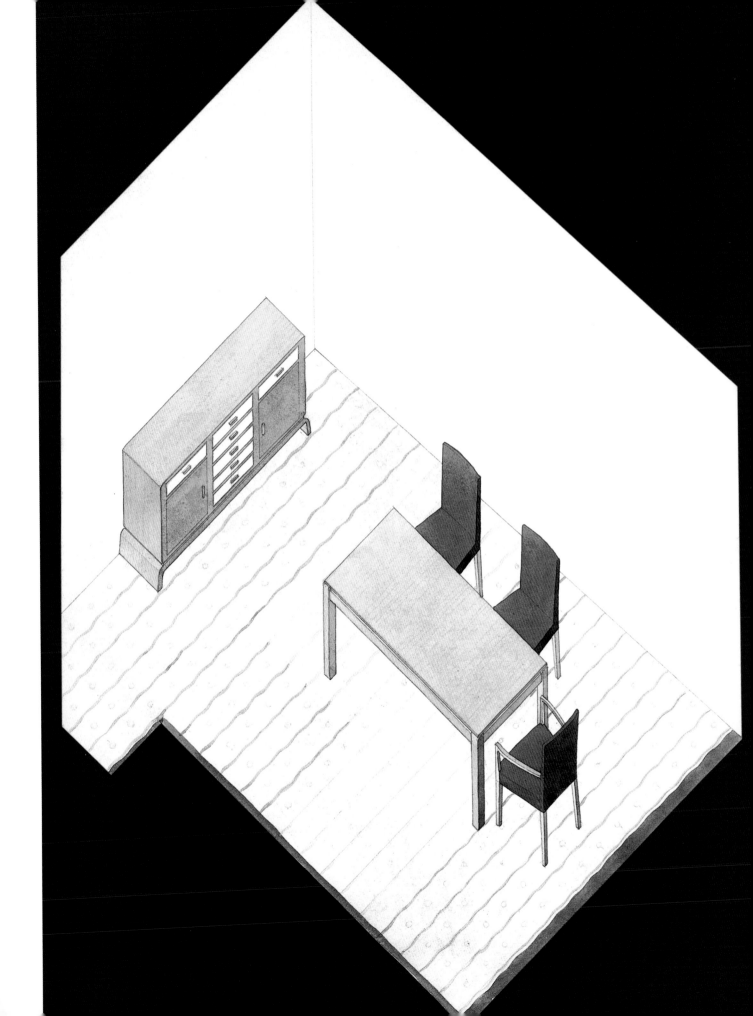

Design for a Tudorbethan dining room, late 1930s

Robert L. Tumelty (worked after 1937 to mid-1950s)

Pencil, watercolour and bodycolour mounted onto designer's board
V&A: E.641–1999

This is a presentation drawing for a dining-room hall. Based on the medieval form of the Great Hall where the large fireplace was the central focus, it was appropriated and scaled down for baronial-emulating middle-class homes. Tudor and Jacobean period architecture were popular revival styles throughout the century, but particularly so in the late 1920s and 1930s when they were taken up by wealthy merchants and city brokers who were acquiring large mansions in leafy suburbs, hence its alternative nickname of Tudorbroker. The design here includes all the right period elements, such as the dark ceiling beams, heavy, solid and ornately carved oak furniture, wall-panelling, exposed dark floorboards and leaded and coloured windowpanes in the bay window. It has been furnished with the appropriate furniture and ornaments – the simulated-candle candelabra and brass candlesticks on the buffet, the painting of a cavalier above the fireplace, and a high-backed, winged cosy-chair next to the hearth, as well as the essential long manorial dining-table to complete the effect. The period look has been given a modern feel by the large plain rug and white-painted, clear-glazed French doors.

Opening onto a paved area with greenery beyond, French doors were important distinguishers in the 1930's middle-class home. Direct access to the verdant outdoors was a conscious symbol of better health and wealth between the large suburban homes of the middle classes and the dark, dingy working-class dwellings of the city.

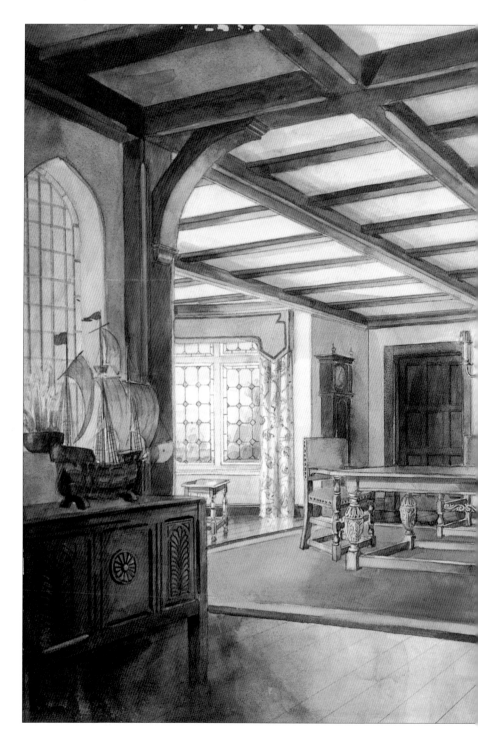

Designs for biscuit barrels, 1940–50

Bernard Leach (1887–1979)

Pencil

V&A: E.1210–1978

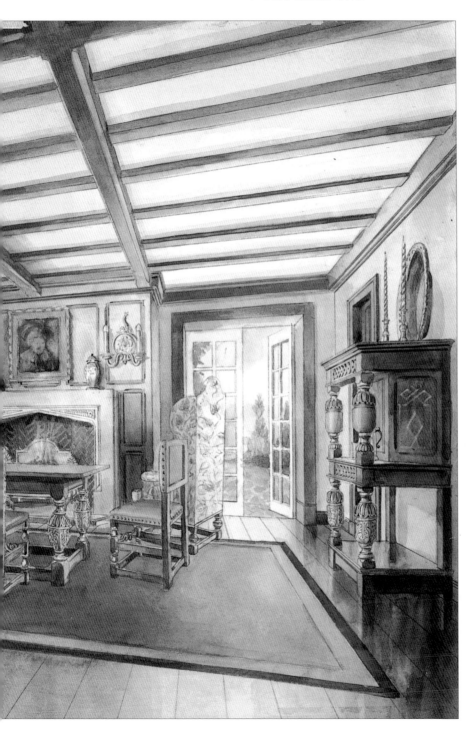

These biscuit barrels are typical of Bernard Leach's style in the middle of his long and influential career. His designs, with their simple, light pencil strokes were, like his finished products, strongly influenced by the Japanese arts he saw and studied when visiting the Far East from 1909. Delicately indicated are the lines around the pots that arise from their method of production (thrown on a wheel), where the technique is directly responsible for the decoration and form of the finished product. Leach integrated Japanese styles with traditional early English pottery, such as country slipware, which appealed to those interested in both traditional medieval and oriental simple forms. It linked in with modern preferences for clean lines and minimal, if any, surface pattern. Concerned with the importance of creative tradition and function rather than fantasy in the making of craft works, Leach encouraged beautifully hand-made products which had a practical function. Ceramics by Leach, like these biscuit barrels, were on sale in Heal's Countryman's Market in 1940, which was set up as a wartime centre for exhibitions and sales of products promoted by the Rural Industries Bureau.

Design for a fitted plywood kitchen, 1945

George Fejér (1912–96)
Watercolour and coloured chalks over dye-line print, mounted onto backing card
V&A: E.791–1997

This is an early design for a co-ordinated fitted kitchen in Britain. Made while Fejér was working for the Selection Engineering Company during the war, the presentation drawing is a 'scheme for pre-fabricated interior elements'. It shows his interest in using newly developed materials in the domestic environment and suggests two types of flooring suitable for their usage in the home: in the kitchen are plywood floor-units with rubber veneer, and the diner is floored in plywood units with a hardwood veneer. The kitchen is part of a radial scheme for four rooms in a house or flat in which walls have been removed and the cupboards act as room dividers. The practical use of space is a priority and there is a handy cupboard for the vacuum cleaner, along with cabinets for the crockery and a fitted radio. With a modern plywood chair glimpsed in the living room beyond, this is an attempt to create a new look and a fundamental rethink of the way in which rooms work. Influenced by the wartime industrial practice of pre-fabrication, this is part of the general idea of the removal of walls, which slowly came into practice during the 1940s, 1950s and 1960s. Fejér's efforts to develop his kitchen designs further were frustrated by the wartime restrictions on wood for building in Britain. His obvious interest in the uses of new surface materials in the domestic sphere led him to be involved with the 1951 Festival of Britain, for which he designed the Plastics and the Rubber stands.

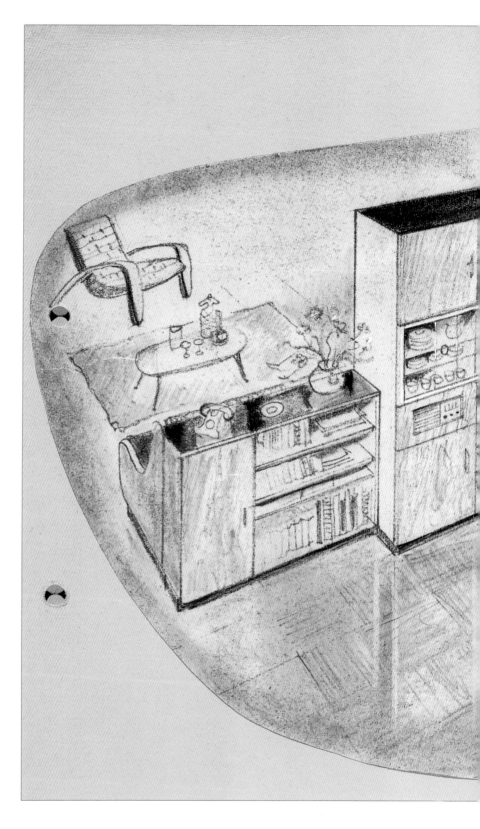

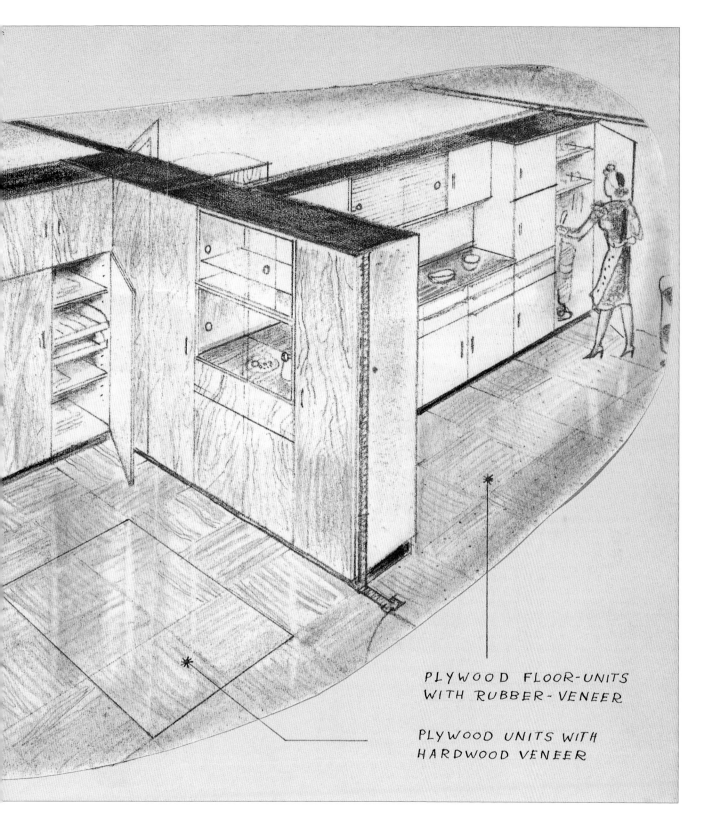

PLYWOOD FLOOR-UNITS
WITH RUBBER-VENEER

PLYWOOD UNITS WITH
HARDWOOD VENEER

… walls have been removed and

the cupboards act as room dividers.

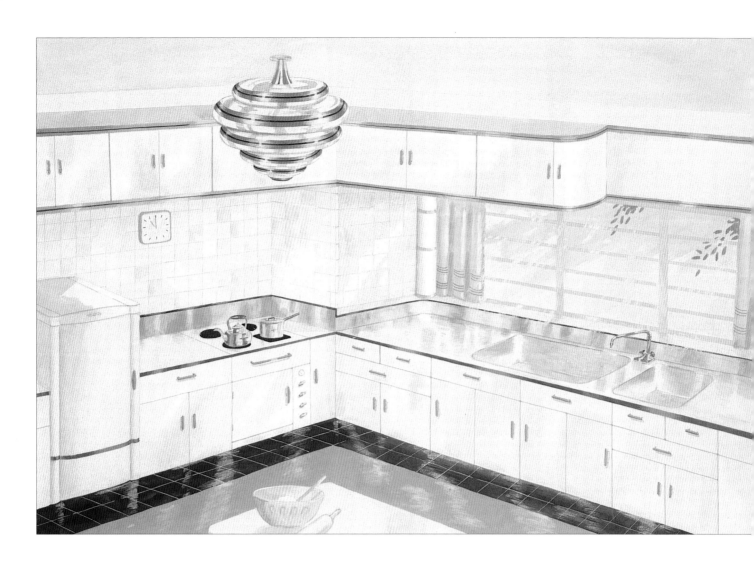

41 Designer's impression of lighting in a kitchen setting, 1945

George Wooller (worked second quarter of the 20th century)
Gouache, pencil and watercolour
V&A: E.1252–1984

This kitchen setting is much more glamorous than the simple, basic kitchen with Utility furniture that would have been available in Britain during the war years. With shiny fitted cupboards elegantly curving around the corners, and gleaming stainless-steel surfaces, this is based on American models of the time.

Containing an electric stove, which would have been the very latest in kitchen technology, it has an oddly contrasting, traditional note with the inclusion of the wooden kitchen table, mixing bowl and rolling pin. Wooller's main interest, however, was the light-fitting, which he patented in 1945. Its shape was derived from the Art Deco form of the chrome-plated metal electric fan heater designed by Christian Barman (1898–1980) for HMV in 1934. Wooller was obviously very taken by this 1930's form, as he produced a whole range of lamps and heaters for most rooms in the house based on the beehive-like tiered shape (as seen in plate 79).

With shiny fitted cupboards ... and gleaming stainless-steel surfaces, this is based on American models.

Designs for ceramic decorations, late 1940s to early 1950s

Roger Nicholson (1922–86)
Pencil, pen and Indian ink, watercolour and Chinese white
V&A: E.2542–1987

In this drawing of alternative designs for transfers, Nicholson used depictions of country life, satisfying the market demand for the rural idyll. Nicholson included notes and comments to the side of each piece, which are useful for understanding the designer's intentions. The border band on the right-hand jug depicts 'An English Village', including a church, cricket on the green, topiary and village houses. The other pieces include spot decoration of a pheasant-like bird, and a large rose with tendrils which are intended to run off the teacup. The soup bowl, with a more modern, geometric pattern, Nicholson believed needed to be lighter in colour. The teapot, with its small floral pattern, is very like contemporary wallpaper and shows the transfer of styles from different decorative areas. Like Eric Ravilious (1903–42), who was prominent in this field during the 1930s, Nicholson used toned-down monochromatic colouring placed onto simple-lined white-ware, giving it that light and clean-cut feel. This type of integration of more traditional images with the modern look of the cups and dishes was very successful in Britain. Designing surface decoration for ceramics and designing the shapes of the ceramic tableware are two distinctive areas and it is probable that Nicholson's involvement with these designs was only in the pattern. Nicholson specialised in pattern design and also produced flat decoration for wallpapers for major manufacturers such as Sanderson's during the 1950s and 1960s.

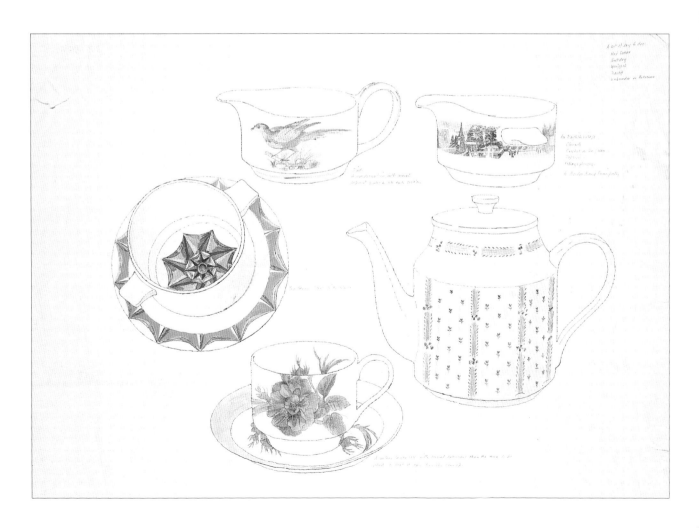

Design for 'The Carefree Kitchen', 1959

John Prizeman (1930–92)

Pen and brush and ink
and Letratone

V&A: E.1136–1979

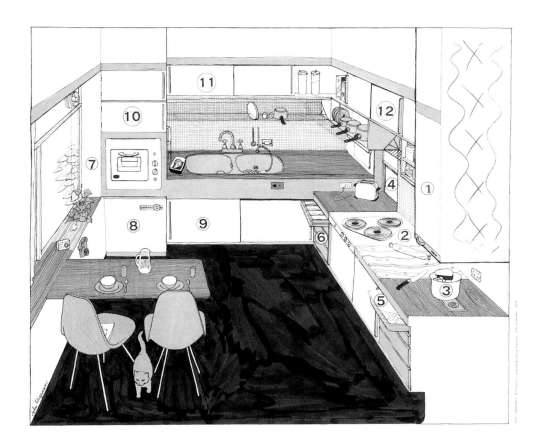

This kitchen is typical of how many family kitchens looked from the 1960s onwards. Published in the *Daily Express* in November 1959, it was subtitled, '... neither a Victorian hangover nor a cold clinic!'. The article went on to suggest that the kitchen was probably the most important room in the house, and was 'a room where things for eating are stored, prepared, cooked, served, washed up and put away'. It highlights the ongoing development and rethinking of the kitchen as a multi-functional centre of family life in the 20th century. The space, which measured 3m x 2.4m, contained all the very latest in kitchen fittings, explained through a numbered key – 1: refrigerator, 2: cooking top, 3: mixer, 4: serving hatch, 5: waste tray,

6: push-through drawers (cutlery, linen, bread), 7: wall oven, 8: washer and spin dryer, 9: vegetables, 10: oven pans, 11: crockery, 12: dry food. The wall oven and separate hob with electric hot plates and the double sink unit (complete with spray attachment for washing dishes quickly) were a new and fashionable development at this time. So were the teak work-surfaces and the collection of electrical appliances, including food processor and toaster, stored on view, and which were seen to be necessary advances in domestic food production and consumption in the late 1950s. Also fitted with a small breakfast table, laid with modern matching crockery with fashionable polypropylene moulded chairs (lightweight, stackable and

wipeable), this was the ultimate in kitchen convenience in a busy family home. Despite being a veritable hub of technology, there is the surreptitious intrusion of ivy tendrils through the open window and, together with the inclusion of the pet cat, introduces an element of nature in this otherwise mechanical environment. It suggests that this kitchen created a certain harmonious existence between the natural and the new. John Prizeman was involved with the Council of Industrial Design in promoting good kitchen design in the post-war decades, and was deeply concerned that kitchens should be effective functioning spaces in the modern family home.

Sketches and working drawings for the Kenwood 'Chefette' electric food mixer, 1964

Kenneth Grange (1929–98)
Pencil and pen and ink on tracing paper
V&A: Circ.838&842–1966

These drawings show some of the different stages in the design process for the Kenwood 'Chefette' which was Kenwood's answer to the 'KM 32' kitchen machine, launched by German rival Braun in 1957. The 'Chefette' is not dissimilar in basic appearance and function, however, Ken Grange developed the convenient handle on the 'Chefette' which made it easier to carry out its multi-purpose functions. The clean-looking, predominantly white colour of the finished kitchen product was important to users, and it became the standard colour for kitchens – bringing about the phrase 'white goods'. In the early 1960s food mixers were symbolic of the ultimate in chic kitchen technology. Every kitchen had one, or aspired to contain one. Kept out on show on the kitchen surface, they became almost decorative ornaments in themselves and were certainly something to be seen and admired. They effortlessly performed what were once tricky food preparations. The fact that they used many different gadgets and attachments which all required extra washing did not deter the housewife, and at the close of the 1990s food mixers still had a large market.

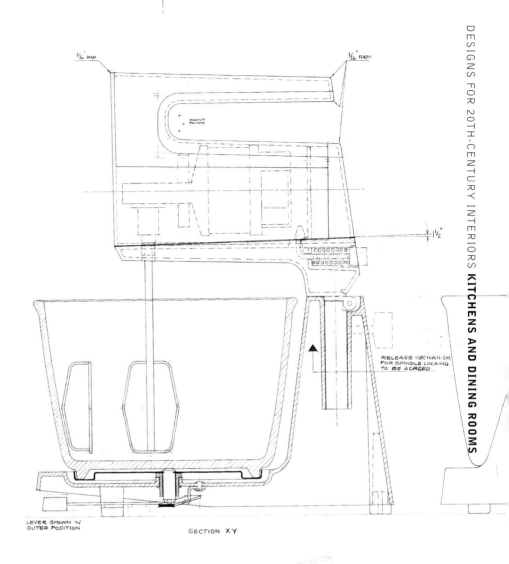

Kenwood 'Chefette' food mixer model A340, stand and bowl set model A342, 1968. Body in white and blue plastic, parts metal, plastic and perspex. Manufactured by Kenwood Manufacturing Ltd.
V&A: Circ.731–1968

Designs for 'Blue Pacific' oven-to-tableware, 1968

Robert Minkin (b.1928)

Felt-tip pen and watercolour

V&A: E.1563A–1977

These preliminary sketches are indications for the shapes and colouring of the 'Blue Pacific' range of oven-to-tableware produced by Wedgwood in 1968. Using the newly developed textured glazes and two-tone colouring scheme, these were among the most popular of the oven-to-tableware ceramics introduced in the early 1960s. The simple, robust-looking but lightweight forms looked to traditional 'Olde English' farm-house cooking pots, and some of the ranges were coloured brown as a heightened historic reference. 'Blue Pacific', however, was a move away from the rural mood to a much brighter and lighter appearance, and

its transparent ocean blue colouring appealed to young homemakers who were part of a new affluent market in homewares. In the accompanying sales material, shown right, the young woman gazes down fondly at her coffeepot, smiling and content. She holds the handle in an intimate gesture as if it was an old friend or she was stroking a cat. She is happy and satisfied to have the object in her possession. These products were designed to express a particular image, with which a particular target market would identify. Oven-to-tableware, which included glass and metal products such as the brand names Pyrex and Le Creuset, were important to the kitchen-diner life-style where food entertaining was held in the eating area by this younger market. The obvious combined benefit of oven-to-tableware was that it reduced the amount of washing up and that it looked attractive both on the dining table and in the 'visible' kitchen.

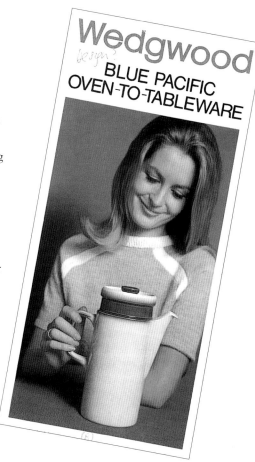

Wedgwood sales leaflet, c.1968.
V&A: E.1563A–1977

Designs for the 'Acorn' range of National Trust products, 1970

Pat Albeck (b.1930)
Pencil and coloured felt-tip pen
V&A: E.637–1980

This sheet of brightly coloured, lively designs for products to be sold in National Trust shops includes ideas for decorating matching merchandise for the kitchen, including a Melinex chopping board, a tin container, oven gloves and a kitchen apron. The patterns, based on the acorn motif (part of the corporate identity of the Trust), are for decorating traditionally plain kitchen items. Once covered in an attractive design, they became objects that people stored in visible positions around the kitchen rather than tucked away in drawers or cupboards. This was one of the first ranges available during the National Trust's rapid increase in commercial sales and marketing from 1970. Pat Albeck was among notable designers who were brought in to develop its merchandising potential. The products were part of the commercial initiatives of the period in marketing the past. The untapped niche for selling heritage products provided rich returns in both Europe and America. It exploited the uninterrupted preference for the style of the traditional idyllic rural past, which manifested itself in the creation of pseudo farmhouse and cottage-like kitchens and dining rooms.

… the style of the traditional idyllic rural past, which manifested itself in the creation of pseudo farmhouse and cottage-like kitchens and dining rooms.

Sketch for 'Add-On Cooking Post', 1972

John Prizeman (1930–92)
Felt-tip pen
V&A: E.1141–1979

This design for a hi-tech, minimalist, space-age cooking station, which resembles a spaceman, could be seen as a humorous take by Prizeman on his own techno-space-age style. It did, in fact, have a practical intention and was produced as a prototype by the London Electricity Board. Intended for the one-room living market, it contained all the essential kitchen equipment, as well as technological commodities such as a television, digital clock and a radio together in one small space. As in his earlier kitchen designs (see plate 43), Prizeman was always forward-thinking in his embracing of technology in the home.

Design for a kitchen, c.1973

Allan Day (b.1939) for Zeev Aram & Associates
Pencil, ink, crayon and watercolour
V&A: E.822B–1979

This is an example of the early 1970's understated techno look. The industrial appearance, with shiny stainless steel framed by dark colour fields and defined by sleek, clean-cut lines, is an overtly masculine environment. The result of the rediscovery of Modernism, it took on a more sophisticated and expensive slant. This kitchen design, incorporating furniture produced by Aram Designs Ltd., includes a larger than usual electric oven with electric hob and hood, with a shiny metal kettle and red pan – giving an indication of the sort of products appropriate in this style-conscious kitchen. The plain, discreet, light-coloured tiled walls and flooring are a conscious rejection of traditional surface pattern, and the half-moon ceiling lamp derives from early Modernist lighting. The overall appearance is sharp, clinically hygienic, uncluttered and cool 'space-age'.

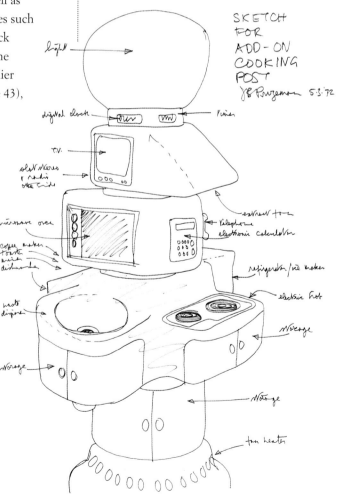

49 (below)

Design proposal for a 'New Outlines' kitchen for Hygena, 1974

George Fejér (1912–96)

Pencil, pen and ink, transferred lettering and toning on tracing paper, stapled to a backing sheet

V&A: E.789–1997

Right:
Hygena kitchen brochure, 1976.
V&A: E.794–1997

Before we design a new kitchen, we spend a lot of time looking at existing kitchens. And we spend even longer finding out what you like and dislike about them.
This has led us to a new concept in kitchen design – Hygena Contour.
Run your fingers over a Contour kitchen and you'll find every surface smooth, and the lines contoured.
Let's take a look at space. We've made every inch of our kitchen work. We've even got cupboards that literally come out

to meet you. In a Hygena Contour kitchen, everything is at your fingertips.
We've also put more choice at your fingertips. More finishes, more colours and a wide variety of work surfaces.
Hygena Contour is designed around your fingertips.

Now for the facts at your fingertips.

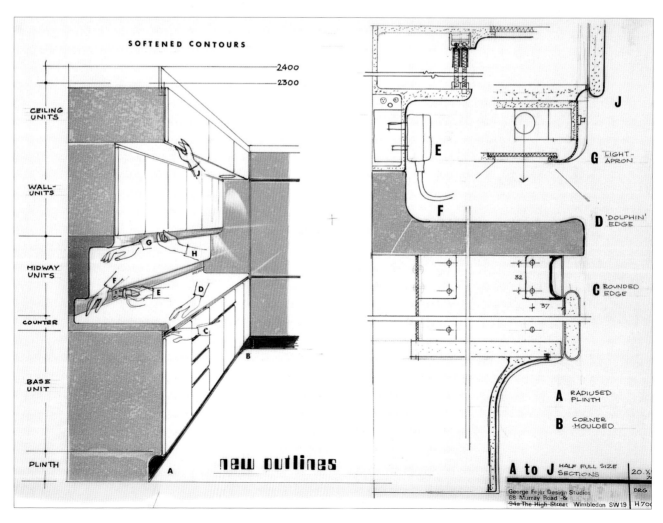

Thirty years after his 1945 kitchen design (plate 40), this is one of George Fejér's plans that did go towards a produced kitchen. Fejér had been constantly developing new ideas for kitchens throughout the 1950s and 1960s, and this design clearly shows how they had changed. He made this drawing while working for Hygena in Liverpool, who had been involved in manufacturing kitchen cabinets from the 1920s and were well-established in the kitchen market during the 1970s and 1980s. By the time this design was made, the basic form of kitchens had been established, with long continuous surfaces over matching fitted cupboards and cookers. The design emphasis shifted to style and, as inscribed on the sheet, the attention in 1974 was on outlines with 'softened contours'. The brochure displays the finished kitchen; though it has changed slightly in the process from design to manufacture, the look and details can easily be identified in the design.

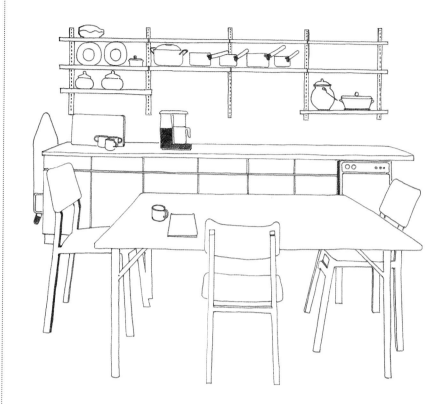

Design for a kitchen, 1976

Conran Associates
Felt-tip pen
V&A: E.1543–1976

Conran Associates, set up by Terence Conran, designed and produced simple, cheap, well-made furniture for the modern, practical home. A combination of the Scandinavian blond-wood style and the Continental look was promoted in Conran's shop Habitat, which first opened in London in 1964. Habitat brought economy and good design together in furniture and furnishings, and made them affordable to young people setting up home. Very influential in interior design and lifestyle from the mid-1960s, Conran was particularly interested in raising the profile of

cooking and the tools of cooking in the British home (he helped to elevate it to 'cuisine'). In this drawing of a wall and table in a kitchen, the pans are stored on easy-to-assemble shelving produced by Habitat. The coffee percolator, prominent on the work-surface, signifies the increasing consumption of coffee, traditionally a more Continental beverage. The mug and book on the table suggests the sociable aspects of this kitchen – elevating it from simply a food-processing space to the Continental tradition of a kitchen as a place to enjoy and to relax in.

Design samples for vinyl floor tiles for Dunlop-Semtex Ltd., 1977

Frank Draper (b.1919) and Peter Evans (dates unknown)
Vinyl paint and varnish
V&A: E.1594,1595,1597–1977

These squares of bright colour are the artwork for the Vynofoam and Vynofoam Super ranges of cushioned vinyl flooring produced by Dunlop-Semtex Ltd. Floor tiles on a roll, they were intended to be used in kitchens and dining rooms as well as in bathrooms and entrance halls. Advertised as being soft to walk on and extremely hard-wearing, they were a cheap, easy-to-fit option, 'giving you a combination of good looks and sheer practical good sense'. The strong colours and striking patterns give them an exotic feel – reinforced by the names given to the range: 'Vulcano', 'Ventura' and 'Casablanca'. Hot oranges with chocolate-brown contrasts and cool shady greens were extremely popular in home furnishings during the late 1970s, and similar repeat patterns were also used in wallpapers and draperies.

Tiles with busy patterns were often based on decorative forms from Middle-Eastern and Asian countries, which became popular travel destinations during the 1960s and 1970s. They would have been used in both kitchens and bathrooms, often on floors as well as walls. The colours would have been co-ordinated to fit in with the kitchen cupboards and other kitchen accessories, and the busy patterns provided a balance to the flat fields of colour on the kitchen cupboards and surfaces. The art of tiling was popular in the 1960s and 1970s, and experiments in tile decoration using different techniques such as screen-printing and vinyl, as well as transfers, were carried out. There was also an interest in moulded three-dimensional tiles, giving a more tactile appearance to a wall, and large decorative tile friezes and panels in concrete were incorporated into homes as forms of art.

Designs for *crudité* dishes, 1982

Matteo Thun (b.1952) for Memphis
Pen and ink, watercolour and body
colour
V&A: E.568–1985

One of the founding members of the
Postmodernist Memphis design group
(1981), Matteo Thun is best known
for his work as a ceramicist. He was
involved with encouraging designers
to use and be inspired by themes
from the past and to draw on the
forms and ideas of different cultures
across the world. These designs for
crudité plates show how, like other
Memphis designers, Thun challenged
traditional concepts of how tableware
should look and behave. Each piece
in the set is different, with individual
character, and yet the group retains a
coherence. None of the sides or
planes of the dishes is level,
challenging the functional properties
of the plates. We are prompted to
question form over function and
decoration, and to reject conservative
expectations of tableware designs.
Thun designed and produced two
other similar ranges of ceramics for
Memphis in 1982, which were given
names of lakes and rivers around the
world.

Design for the manufacturer of a teapot, 1995

Eleanor Kearney (b.1966)
Photocopy of a drawing
V&A: E.643–1998

Teapot, 1995. Pewter and polished oak.
V&A: M.12–1998

This photocopy of a drawing (left) shows the final instructions to the manufacturer for Eleanor Kearney's elliptic pewter teapot. The teapot evolved from the independent craft tradition of design joined together with industrial manufacture. Kearney initially conceived and produced the teapot with a rounded base, which sat on a receptacle on the table.

Originally inspired by the stacked forms of a castle on a rocky outcrop in a Spanish plain, the ideal form proved to be impractical for a pot holding hot liquid, which had to be frequently lifted and set down. To change the design, Kearney photocopied the original technical drawing and worked on changing the shape to give the teapot a flat bottom without losing the essential form and balance of the original.

Although not catering for the mass-market, it was taken up by the late 1990's admirers of highly designed craft works, and was part of an increase in interest in using pewter for household products.

Three-dimensional CAD designs for the Zanussi 'Oz' refrigerator, 1997

Roberto Pezzetta (b.1946)
Colour laser print
V&A: E.74–2000

These three-dimensional CAD (Computer Aided Design) drawings were produced during the design engineering process of the 'Oz' fridge. Originally conceived by Roberto Pezzetta, Director of the Zanussi Design Centre, the initial concept for the shape was developed by the Design Centre using a simple two-dimensional CAD program, which mapped out the basic form. The form itself was based on a fertile, pregnant shape, rendered in colour rather than the traditional white as preferred by the majority of people polled in

-dimensional CAD-generated
laser print, 1998. Marketing
of 'Oz' refrigerator.
E.101–2000

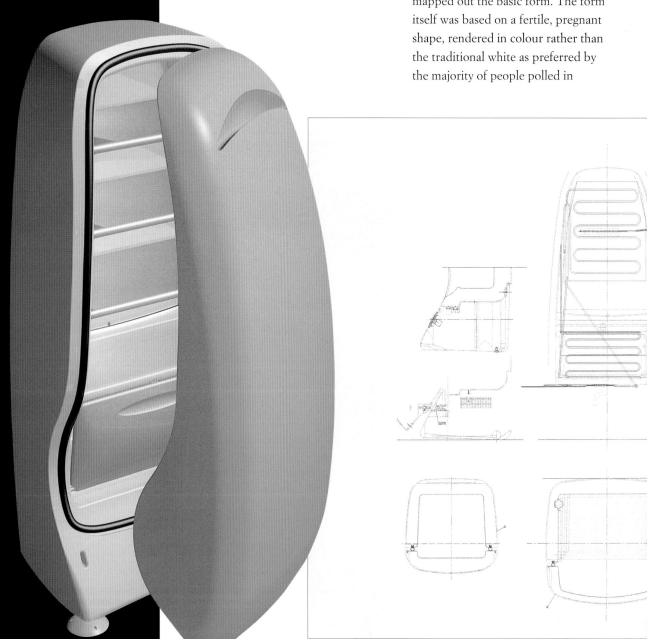

market research. Through this study, the team also found that many people liked the 'duck-egg' blue for a fridge as it conveyed an idea of freshness.

Changes to the design concept were made in consultation with both the Zanussi marketing and engineering teams, and then developed by using a more complex three-dimensional CAD package, which was able to map out all the complex contours of the surface modelling. This sheet shows a variety of elevations where each coloured track corresponds to the same line in each example, and gives

an accurate visual description, without the surface, of how all the internal components relate to each other.

'Oz' is part of a range of kitchen products that are being developed by Electrolux-Zanussi at the Design Centre in Italy, including the 'Teo' oven and the 'Zeo' washing-machine. Zanussi have given names to their products as they believe that people personalise their relationship to domestic products. As part of the move away from fitted kitchens at the end of the 1990s, the 'Oz' fridge was not intended to be fitted into a linear

rigid plan of cupboards and continuous work surfaces. To take this flexibility further, it is also thought by the designer and manufacturer that it can sit comfortably in any room in the house, such as the living room or a bedroom. This, like the Azumi 'Table=Chest' (plate 27) is part of the culture for unfixed furniture that is non-room specific. And so it fits easily into the multi-functional living areas – in both space-restricted homes and spacious loft-living – of the late 20th and early 21st centuries.

Bathrooms

Utility or luxury? Bathrooms are used in many different ways. They can be an extension of the living room, a modern boudoir or a sanitary powerhouse. Whether the bathroom is a private retreat or family forum, a place for cleaning and grooming or for relaxing and rejuvenating the soul, its use is reflected in the way it is decorated.

The bathroom as an architectural space did not exist in the middle-class home until the end of the 19th century. An allocated space for bathing had existed in houses of the wealthy upper-classes, without plumbing, since the 16th century, but the improvement in water supplies and sanitation eventually demanded a space for the plumbing fixtures in all homes. Previously, ablutions were carried out with water in portable containers such as buckets and ceramic jugs and bowls set on washstands, usually in the bedroom and sometimes in the kitchen. Newly developed showers could be found in wealthier middle-class homes from around the turn of the century, but in most poorer homes a tin bath in front of the hearth was all that was available, in some cases until as recently as the 1960s. These were often stored on the back wall of the house and shared between two families.

Toilets initially took the form of portable chamber pots (stored in pot cupboards or under the bed at night). Wealthier households may have had a commode made to look like a smart piece of wooden furniture with a pan set into the seat, a form which had been used for more than 200 years. These were often kept in the water-closets (WC), which had existed in wealthy houses since the 16th century and was often referred to as the 'privy'. The first fixed toilet bowls in middle-class homes were usually in a separate space of their own. In working-class homes they were usually outside the house, in the back garden or yard, though in some slums where there were no gardens they were built in the street for communal use.

So what brought about the changes? The provision of an internal room especially designed for carrying out daily ablutions resulted from a combination of factors. At the turn of the century basic social sensibilities demanded a higher level of cleanliness than previously practised. This largely arose from religious teachings that promulgated the moral virtues of cleanliness. In addition, there was pressure from the evolving Public Health Movement, bolstered by the scientific recognition of the water-borne transmission of several major infectious diseases, such as cholera, typhoid and polio. Such diseases were rife in poor, overcrowded living quarters, where the air-

borne tuberculosis was also common. Awareness of public hygiene eventually increased, and improvements in plumbing and the building of sewers increased the number of households that received fresh, running water and were able to dispose of waste. The development of water-heating technology made frequent washing easier and more pleasant. By the end of the 1920s the issues of cleanliness and hygiene were also promoted by journalists and advertisers, and so gave rise to the product world that accumulated around them (although some items, such as soap, were being advertised in the early 1900s). As a result of all of these forces, bathing became a much more regular activity as the century progressed.

The bathroom is an index to civilisation. Time was when it sufficed for a man to be civilised in his mind. We now require a civilisation of the body. And in no line of house building has there been so great a progress in recent years as in bathroom civilisation.

'Bathrooms and Civilisation', *House and Garden* (February 1917) vol. XXX, no.2, p.90

Once the bath and toilet became fully plumbed-in fixtures, they required an allocated internal space. A standard inclusion in newly built houses in the first decade, and with add-ons and conversions of existing rooms, internal bathrooms were a regular part of the home environment by the mid-1920s. At first they were decorated in much the same way as other domestic spaces, with carpets and curtains. By the early 1930s, hygiene in the home was the buzz word in marketing home furnishings, and bathrooms took on a look of their own. The recent technical developments in materials such as non-porous vitreous china and tiles, glass, rubberised flooring and shiny, non-rusting, chromium-plated steel, meant that practical furnishings were available and the bathroom could be made a clean and hygienic place. At first the use of white fittings emphasised the spotlessly clean look. This look was also derived from the precedent classical Roman baths. Roman and Greek motifs and, of course, the use of white marble, were therefore seen as appropriate bathroom decorative styles. America was at the forefront of plumbing fixtures developments from the first decade of the 20th century, and the emerging American bathroom was an overtly industrial ensemble of porcelain-enamelled equipment with white, washable surfaces that reflected contemporary theories of

hygiene. Later in the 1930s, advertisers pushed the use of colour to person-alise and soften the industrial look but, largely due to expense, this was not popular in Britain until the post-war enthusiasm for acquiring 'civilised'-look-ing bathrooms in the 1950s.

In Britain, a landmark in the use of these new materials in bathroom deco-ration was designed in 1932 by Paul Nash for the famous dancer of the day, Tilly Losch (see plate 59). Nash, an avant-garde painter and designer, revolu-tionised the look of the bathroom with an exciting use of colour, surface textures and lighting in a Modern style.

Throughout the 1930s there was a proliferation of marketing pamphlets and advertisements in newspapers and magazines for bathroom furnishings and fittings. Colour schemes for bathroom suites and tiles tended to be in pastel shades of jade green, forget-me-not blue, pink and yellow. Often a combination of two colours was used and in the more striking Jazz Modern style bathrooms, black tiles were introduced as a sharp contrast using geo-metric patterns. But it was not until the early 1950s that the real era of the designed bathroom as a popular commodity began in Britain. With the influx of American goods, British tastes changed. In the late 1950s and 1960s newly developed plastics and laminates were found to be useful waterproof surfaces in the wet environment of bathrooms: they also had the added advantage of coming in bright, fresh colours, which British homes were keen to use after the austerity of the 1940s.

In Britain in the 1960s and 1970s, home ownership rapidly increased with the building of new satellite towns, and once again bathroom design and decoration received much attention. Public bodies such as the Council of Industrial Design published advice on how to arrange and decorate the bathroom (with the intention of raising standards of bathroom design). Interestingly, they acknowledged the neglect of the bathroom in comparison to other rooms, and highlighted its significance in the home. By the late 1960s and early 1970s, further advances in plastics technology enabled designers to produce the complete vacuum-formed bathroom, incorporating walls, floor, bath and sinks, but this was not a market success. The concept of the prefab-ricated bathroom was not new – it was first proposed as early as 1938 by the American inventor-designer Richard Buckminster Fuller (1895–1983) with his 'Dymaxion Bathroom'. It seems, however, that both the building trade and homeowners preferred a site-made bathroom which could be flexible and

personalised. Plastics were used much more for individual basins and baths, and their shapes began to change, albeit subtly, reflecting the more flexible properties of the materials. For those for whom money was no object, the 1970s also saw the revival of the sunken plunge bath in luxurious marble-lined bathrooms.

The later 1970s and 1980s saw the de-mechanisation of the bathroom. With designers such as Terence Conran promoting simple Scandinavian blond-wood style bathrooms, they became less technologically orientated. There was also a heritage-inspired revival for freestanding pieces of furniture; designers started to approach the look of the bathroom in a more artistic way.

It was not until the 1990s that bathrooms became important social spaces and more or less took over from the kitchen as the place to display the contemporary taste of the homeowner. With the loft conversion boom, the arrangement and placing of bathrooms in the living scheme became more flexible, and in some cases they were part of open, boundary-less living spaces. As well as the stark, white-walled, blond-wood floored look that was common in lofts, there was also an interest in playing with historic forms and there was a revival in historic features such as freestanding baths on legs. By the end of the 1990s the concept of keeping water within the bounds of a bath or shower unit was being challenged. Bathrooms were becoming 'wet rooms', where a shower in the centre of a tiled space, with floor drainage, was the ultimate experience in bathing at the end of the 20th century.

Designs for bath taps and pipes, 1900

Nelson Ethelred Dawson
(1859–1942)
Pencil and watercolour
V&A: E.717–1976

Right: Taps, 1900. Coppered
and silvered Britannia metal.
Manufactured in Birmingham.
V&A: Circ.191A-D–1963

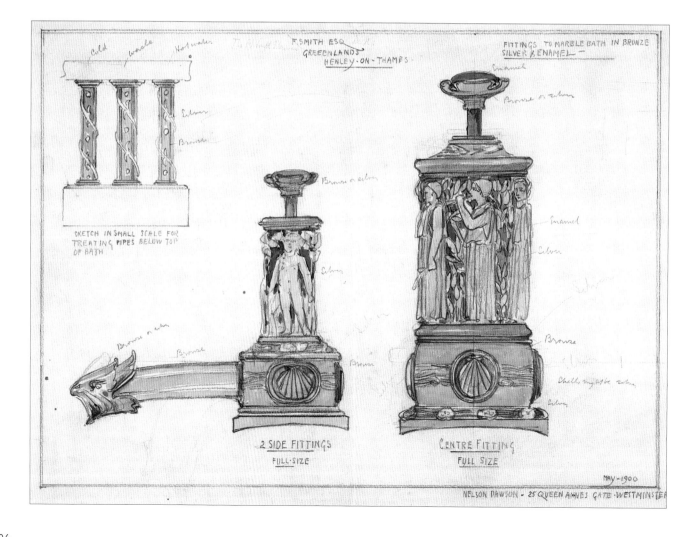

Domestic baths with taps were a luxury item in Britain at the beginning of the 20th century. These taps, designed by Ethelred Dawson, are particularly ornate examples of early bathroom fittings. Dawson and his wife Edith (1862–1928), who was responsible for enamelling in the workshop, were greatly influenced by both the style and the work ethics of Morris & Co., and practised in a wide range of decorative metalwork (as seen in plate 2). These elaborately decorated and sculptural taps, with elegant maidens and grotesque animal-head spouts, show the persistence of Arts and Crafts and Art Nouveau into the early years of the 20th century. The forms are derived from precedent examples found in fountain spouts of the Renaissance. The rendering is a highly finished presentation drawing to show to the client, William Frederick Danvers Smith, 1st Viscount Hambleden, who commissioned the taps for his house Greenlands in Oxfordshire. The taps were hand-made in Dawson's workshops rather than on a production line, which meant that they were very expensive to produce. Both Dawson and his wife trained in art schools, as did many designers of the day, which is why this design drawing has a particularly painterly feel to it.

Design for the bathroom in the 'House of an Art Lover', 1900

Hugh Mackay Baillie Scott (1865–1945)

Published in *Haus Eines Kunst-Freundes*, from the series *Meister der Innen-Kunst* (1902, vol. I, pl.x)
V&A: L.200–1902

Baillie Scott's version of Arts and Crafts had a strong medieval look. Influenced by other designers such as Archibald Knox (who was his teacher) and C.F.A. Voysey (see plates 32 and 73), his designs also showed the influence of Art Nouveau. His style was greatly admired by Hermann Muthesius (1861–1927), and in 1902 his winning entries for the competition to design the 'House of an Art Lover' were published in Muthesius's '*Haus eines Kunst-freundes*' (see also plate 29).

Muthesius, based at the German Embassy in London from 1896 to 1903, was researching British housing for the Prussian Board of Trade for Schools of Arts and Crafts, of which he was superintendent. He was greatly impressed by Baillie Scott and Mackintosh, and the influence of British Arts and Crafts can be seen in the work of the Deutscher Werkbund which Muthesius helped found in 1907.

This plunge bath designed by Baillie Scott for the competition is like a secret sunken pool in the medieval manor house. The columns and use of marble are unusual for Baillie Scott, who used a lot of wood in his interiors, and reflects materials which were fashionable in wealthy bathrooms of the period. Marble, however, was soon to disappear from popularity as its non-porous surface was thought to harbour germs and therefore didn't stand up to the sanitary scrutiny of hygiene-conscious campaigners and homeowners.

Scheme for a bedroom converted into a bathroom, late 1920s to early 1930s

Hampton's Sanitary Fittings brochure, Hampton & Sons Ltd., Pall Mall East, London, p.505

V&A: L.6502

For the home that didn't have a purpose-built bathroom, Hampton's brochure demonstrated how a bedroom could be easily converted into a smart modern bathroom. They assure the prospective client that it can be installed with equally satisfactory results in either a town or country house. The alcove on the left was originally for the bed. The spotless white fittings were the preferred colour at this time, reinforcing the impression of cleanliness and hygiene in the home. Note the sitz bath (hip-bath) at the far end of the room, complete with metal ladle, a hangover from late Victorian bathing habits. The Greek key-pattern frieze around the walls and the waterproof curtain give this scheme classical overtones. This exotic touch is reinforced by the large natural sponges held in metal baskets at the head of the bath. The tiles around the bath are green glass, while the flooring is the very latest in hardened India rubber, which the catalogue is keen to point out is 'absolutely waterproof, at the same time … warm and impervious to wear'. In the same brochure there is an advertisement for a luxurious, marble-lined plunge bath, which is not very different from Baillie Scott's version in plate 56.

Design for a Roman bathroom, early 1930s

B.Carpenter (active 1930s)
Pencil and watercolour
V&A: E.305–1998

This fantastic bathroom is fit for an emperor or empress. The elaborate wall treatment, with painted columns entwined with laurel garlands and a laurel wreath containing an emperor's head, appears to be inspired by a romantic Hollywood film set. It also fits into the traditional style of bathroom decoration as set by Roman baths and seen to be appropriate in the 20th century. The historical elements are not intruded upon by the subtle ceiling lamp, of a much more modern taste, based on the model of this type first introduced by Ferdinand Kramer at the Bauhaus in 1926. Note the bath with a skirting around the base to hide the feet; this was to prevent dust getting under the bath in response to complaints that this space was difficult to access for cleaning. By the mid-1930s they were fitted with full panels that boxed in the bath and plumbing.

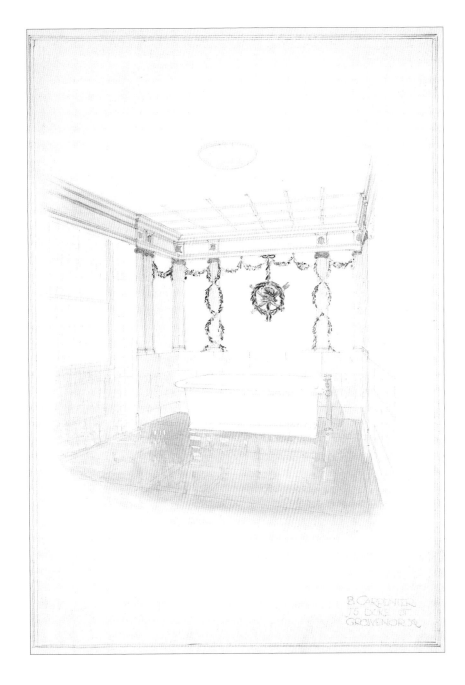

... with painted columns entwined with laurel garlands and a laurel wreath ... appears to be inspired by a romantic Hollywood film set.

Carpenter, who had an office in Grosvenor Square, London, worked for a middle-class clientele throughout the capital and the south-east of England, where many *nouveau riche* merchants and bankers retired by the sea and built their dream homes.

Tilly Losch's bathroom, 1932

Paul Nash (1889–1946)
Photograph previously taken of
V&A: W.12–1981

Tilly Losch's bathroom caused a great sensation. Designed by the avant-garde artist Paul Nash for the dancer's London home at 35 Wimpole Street, which she shared with her new husband, Edward James, it looked like no other bathroom seen before. It was the cutting edge in its use of new materials and style, and was in sharp contrast to Nash's earlier work for the Omega Workshops. The *Architectural Review* of June 1933 thought it remarkable:

> The room is particularly interesting because it represents a departure from the normal use of polished glass for wall lining. The effect is produced by using inch thick Stippled Cathedral glass, which is pure white, but treated with 'alloy' silvering which produces a deep metallic purple colour. (The great advantage of using glass having a comparatively rough surface is that condensation is practically invisible, and at the same time the work of cleaning the glass is very much easier.) The depth of colour over the greater area is relieved by panels of peach plate mirror which give clear, warm reflections.

The doors and electric radiator were featured with silvered Reeded glass alloy (a treated glass), and all other metalwork was chromium plated. The dark, exotic room was finished off with black glazed earthenware sanitary fittings and new tube lighting. It was also fitted with a tilting ceiling mirror and a chromed-steel ladder as a practice barre for Miss Losch. While this bathroom was under construction, Edward James was having a new bathroom designed for himself, in a very different style, as can be seen in plate 60.

...caused a great sensation ... it looked like no other bathroom seen before. It was the cutting edge in its use of new materials and style ...

Design for the bathroom decoration for Edward James's London house, *c.*1932

Geoffrey Houghton-Brown (1903–93)
Pencil, pen and ink and wash,
watercolour and bodycolour
V&A: E.32–1987

Geoffrey Houghton-Brown's bathroom mural was an avant-garde, surreal play on periods and style that would have greatly appealed to his patron, the bohemian and contemporary art collector, Edward James. The *trompe l'oeil* picture of a nymph in a grotto surrounded by architectonic elements is based on murals from Pompeii, but Houghton-Brown gave it a rather stark and modern touch. This is one of a number of designs that were prepared for the bathroom, and is the one that was actually executed. Houghton-Brown was a well-known decorator of the day who was influenced by French avant-garde fashions for *objet trouvés*. His style contrasts with the bathroom James commissioned for his new wife, the dancer Tilly Losch (plate 59).

61 (opposite)

Design for a bathroom interior, *c.*1935

William Henry Haynes & Co. (in business from *c.*1870 to *c.*1970)
Watercolour and ink on board
V&A: E.8–1977

The pink and black contrasts in this presentation drawing for a bathroom clearly show the striking and effective look of the mid-1930's Jazz Modern style. Born out of Art Deco, and more commonly taken up in America, this was a very modern and expensive statement to make in the bathroom at that time. There are some commonly used Art Deco forms here, such as the tiered treatment of the top of the mirror, where the architectonic shape refers to the 1930's urban American landscape of soaring skyscrapers. Both the tiered forms and the running lines of the parallel mouldings around the bath were derived from the architectural forms of the Aztecs and the Mayan cultures of South America that were being excavated around the same period. Note that the side of the bath is now completely boxed in, straight and flush with the ground – any sign of the mechanics of the bath are gone. Shiny new tiles have been used extensively. It was important that commodities were co-ordinated down to the last detail in order to create the right look, and fittings such as soap-holders, cups, towel rails and mirrors were by now readily available in matching sets from the main manufacturers. The Greek key pattern is used here again, along the trim of the hand towel, and was part of the Art Deco interest in, and appropriation of, ancient forms but was also a typical motif used in bathroom decoration during the decade. The metal-framed bathroom stool perfectly completes the ensemble with its overt reference to new, shiny, machine-age produced objects. It probably has a cork seat in it – a popularly used material with great practical qualities for use in wet areas of the home.

Bathroom in the Ashopton Inn, 1940

Kenneth Rowntree (1915–97)

Pencil, watercolour and bodycolour
V&A: E.1267–1949

This watercolour records a good example of an unmodernised bathroom. Although it is an existing bathroom in an inn, it is furnished with the same sort of bathroom fittings that would have been found in many private homes. The large, chunky hand-sinks with undulating sides and bulbous brass taps were typical of 1920's fittings. The wainscoting around the walls and side of the bath was a popular traditional and cheap way of providing waterproof surfaces, although water marking can be seen around the back of the sinks. The bathroom has obviously been converted, as the plumbing has been fitted rather crudely partly around the wall. The garret window has been roughly boarded up, possibly for the wartime blackout, although an intrusive ivy is making its way in from outside. While the mirror is an old framed one from above a mantelpiece, the window glass looks like a more modern squared opaque type. The flooring, probably linoleum, is also decorated with a bright new pattern which, together with the bright red bath mat, adds a colourful touch to the otherwise dull room. It is certainly not a modern bathroom and would have tried the hygienic sensibilities of many housewives. This bathroom style, with the wainscoting, was a look later revived with the influence of heritage styles and Scandinavian modern design in the late 1980s and early 1990s.

The watercolour was painted as part of the Recording Britain campaign during the Second World War, when artists were commissioned to record for posterity buildings thought to be part of the British heritage and whose existence were under threat. Rowntree's attention to detail here even includes the reversed letters of the back-to-front bath mat.

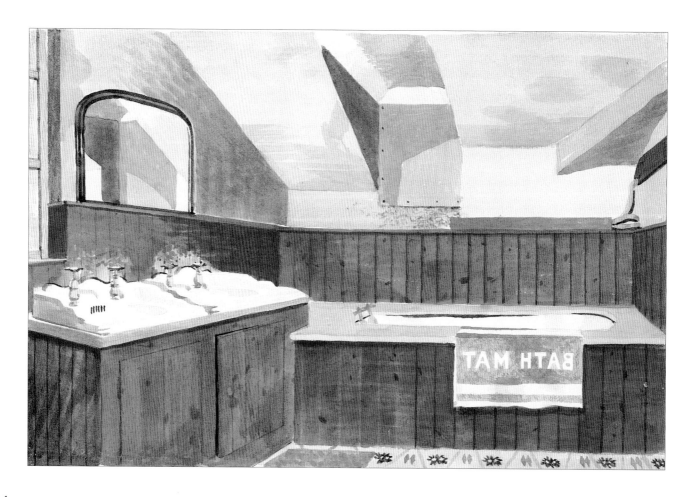

Design for a bathroom suite, 1962

Knud Holscher (b.1929)
and Alan Tye (b.1933)
Felt-tip pen, grey bodycolour with crayon, and photograph
V&A: Circ.28–1966

This toilet bowl, bidet and hand-basin set look more like sculptural forms than practical bathroom fittings. They are in fact clay models, photographed and attached to presentation drawings which Holscher and Tye submitted to an international competition for sanitary ware design, organised by the International Union of Architects. The competition laid down three requirements: that the design should be aesthetically pleasing when installed, that it should be functional from the user's point of view (rather than for the convenience of the plumber), and that it should be easy to produce and install. Underneath the photographs are drawings of alternative arrangements for the sanitary ware, to fit differently shaped bathrooms. Holscher and Tye's designs won first prize and were later produced as the 'Meridian One' range by Adamsez Ltd., launched in 1964. The following year the range won a Council of Industrial Design Award, and the finished products were later featured in 1966 in *Bathrooms*, a Design Council publication, promoted as examples of good design.

This form of bowl, which fitted flush with the wall and therefore concealed all the plumbing, was a popular look in the 1960s and 1970s.

It presented a neat finish to the appearance of the bathroom, contrasting to earlier designs in which pipes were prominent. The 'Meridian One' range had the advantage of being made of lightweight vitreous china, and was designed to be fitted to a tiled wall without the need for cutting the tiles. As such, it was the perfect combination of style, practicality and convenience.

Illustration in *Design* magazine (June 1965) no.198, p.51

64 (left)

Design for a bathroom for the 'Take A Room' series in the *Daily Telegraph Magazine*, 1968

**Designed by Max Clendinning (b.1930)
and drawn by Ralph Adron (b.1937)**
Poster colour
V&A: E.827–1979

The aerial view of this modular bathroom gives a clear view of the compact layout. The designer thought it was better to move all the fittings into the middle of the space, making the room cosier and more attractive. Prefabricated, so that it could just drop into the existing space, the unit was intended to be lined with white plastic and the floor covered in white PVC tiles. The unified fittings and storage systems supplied generous room for soap and bottles, while the towel rail was heated. Clendinning felt that the positioning of the bath in the middle gave the bather a sense of enclosure and privacy. Behind the double-sink unit are the shower on one side and the WC on the other, and the exotic-shaped bottles with brightly coloured contents give the bathroom the appearance of a tropical fish tank. The geometric forms and flowing contours, typical of Clendinning's style, are emphasised by Ralph Adron's striking rendering style. The whole scheme was part of the 1960's fascination with prefabricated rooms and units.

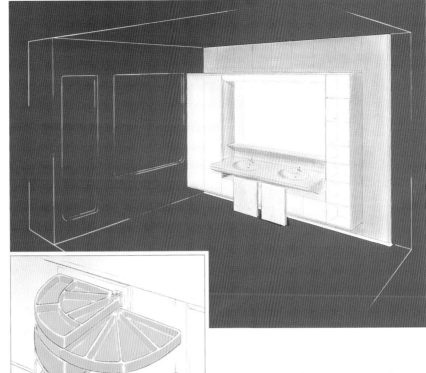

65

Designs for a bathroom sink unit and a swing shelf unit, 1974

Professor Arnold Schurer (b.1929)
Watercolour and chalk drawing, pasted onto chalk drawing on a brown background sheet; pencil and yellow watercolour
V&A: E.1019&1020–1979

These designs for a swing shelf unit and prefabricated double-sink unit were part of the 'Bad 3000' ranges designed for Poggenpohl Ltd., Germany, by Professor Schurer and also marketed in Britain. Previous attempts by designers to introduce the use of prefabricated rooms, or parts of rooms, had failed in the 1930s and 1950s. This 'new bathroom program', however, was advertised as a convenient way to easily create the bathroom you want through the arrangement of different ready-made units. The attractive yellow and orange of these units was a bright and fun 'pop' addition to the mid-1970s, and the use of moulded plastic in the shape of a fruit segment for the vanity drawers brought a humorous though practical element as it was lightweight and easy to clean. The efficient use of space for storing all the gadgets and products that people were being encouraged to buy was an important issue by the 1970s.

Beginning in the early 1920s, Poggenpohl was one of the first companies to produce standardised kitchen and bathroom units in series in Europe. During the 1960s they introduced modern strip handles and covered their cupboards in brightly coloured, gloss-laminate finishes.

66

Sketches for Crayonne Bathroom Range, 1976

Drawn by Howard Chapman for Conran Associates
Pencil and felt-tip pen
V&A: E.1539–1976

These drawings show the designs for part of a range of bathroom accessories (including wall-mounted soap and sponge holders, hand-towel ring, towel rail, alternative designs for toilet-roll holders and toilet brush and stand) which was commissioned by

Crayonne. Entitled 'Clip on bins – trays', the rendering shows how easy the products were to fit together and maintain. The accompanying advertising brochure stated, 'With the Crayonne Bathroom Range you have somewhere to put everything which leaves more room in the bathroom for you'. The finished products came in fawn, white, 'refreshing' pink and blue, which at the time were cutting-edge colour treatments. Made in polished ABS plastics, it had the added advantages of being scratch-resistant, shatterproof, non-corrosive and easy to clean around. The range, which was not at the cheap end of the

market, could be bought in total or as separate items, but the marketing emphasis was on its advantage as a space-saving, co-ordinated, continuous system which could be easily put together by the homeowner.

The rounded forms copy ceramic precedents for fittings of the same kind. Despite the fact that plastic could be moulded into almost any conceivable form, it was often the case that when it was introduced as a new material into an established area it copied the traditional form before establishing its own distinctive shape. Although plastics had been used as surfaces in bathrooms since the 1950s, plastic goods were not at first popular in homes: its lightness and fragility, despite its obvious waterproof properties, was somewhat distrusted. There was also a certain British discomfort with throw-away products, which much plastic merchandise encouraged. Its advantages, despite its initial expense, eventually won its place in the market and in most homes, and the Crayonne rounded forms were very characteristic of mid-1970s plastic domestic products.

67 (opposite)

Design for bathroom furniture and accessories, 1976

Conran Associates
V&A: E.1547–1976

This is another Conran Associates design, this time for a complete bathroom and accessories scheme. A rejection of the hi-tech, this bathroom has a more ordinary look, rather than a machine for washing in. Influenced by the Swedish style, it has a pine-slated bench, like those

found in Scandinavian saunas and which became popular in Britain during the 1970s. The inclusion of wooden, freestanding furniture, such as the traditional kitchen chair seen here, was a major shift. From the early 1980s many bathrooms in Britain looked like this, due to its

Design for a shower, *c.*1981

Ettore Sottsass
(b.1917) for Memphis
Coloured chalk and felt-tip pen
with tracing paper overlay
V&A: E.565–1985

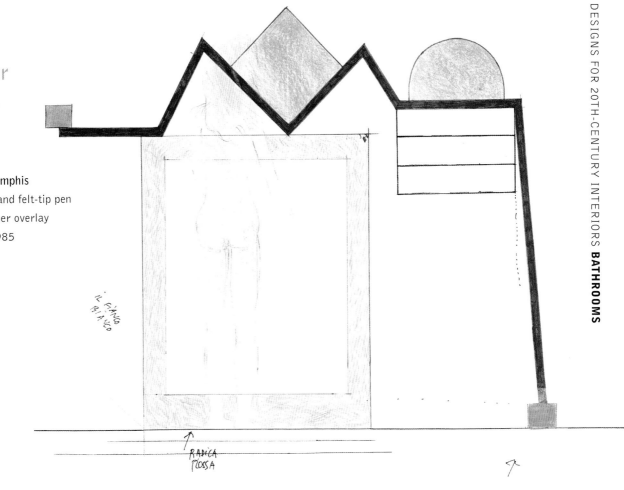

Ettore Sottsass continued his Postmodernist design, as seen in the chapter on Living Rooms (plate 23), into the bathroom environment. This shower, decorated with colourful zigzag geometric lines, is a prime example of his exploration of untraditional forms in an attempt to create new ways of expressing objects in our everyday landscape. Sottsass's scheme runs contrary to most people's expectations of how a shower should be decorated. His Post-radical approach explores the aesthetic possibilities of mass environment with textures, patterns and materials used traditionally in other artistic and industrial areas.

ease to assemble and cheapness. The rubber duck on the side of the bath is an example of the more humorous decorative elements which became popular from this period. The minimal, uncluttered look suggests a clean and fresh, healthy feel, and also appealed to the austere and traditional elements of the British consumer market. This bathroom is definitely, however, for the modern

lifestyle with an electric hairdryer in the cupboard.

69 (right)

Design for a bathroom, 1986

Stefano Mantovani (dates unknown)
Watercolour and gouache over
dye-line print
V&A: E.295–1986

One of a series of Postmodern room designs by Mantovani, this is a 1980's Italian interpretation of 1960's Pop Art, in which fun elements play in the furniture and all is not what it seems. There is a distortion of proportion and function, with cupboards resembling huge medicine bottles and stripy hangings which are really laminated *trompe l'oeil* sliding doors. The blue and white chair with 17th-century style legs opens up to reveal a medicine cabinet. This is storage at its most bizarre. The whole feel of the room is that of a sports pavilion or beach hut, with a sense of energy and the suggestion of clean sporting whites. The surrealism of the bathroom is emphasised where the huge pavilion window becomes a mirror which daily reinforces the user's vanity with the words 'You Look Lovely'.

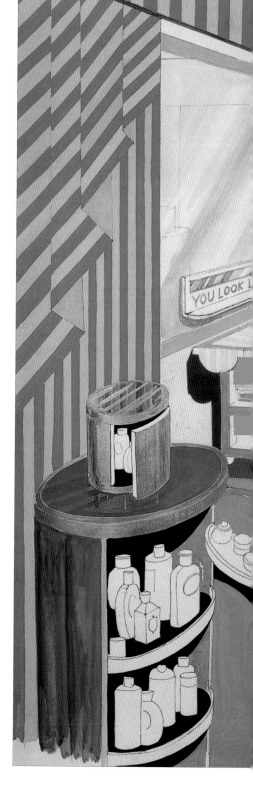

70

Sketch for a bathroom in the Lidingö house in Stockholm, Sweden, late 1994

Thomas Sandell (b.1959)
Ball-point pen, in a sketchbook
V&A: E.631–1999

This sketch for a bathroom in Stockholm shows the Scandinavian blond-wood look combined with modern tiling and a revival bath tub. The client's brief specifically asked for a freestanding bath tub to be the main feature of the room, and so Thomas Sandell positioned the white enamel bath jutting into the centre of the room. The walls are in white-painted pine with areas of light blue dotted with red mosaics, with the flooring completed in ivory-white ceramic tiles. With a fitted twin sink unit and large mirror on the wall, the room has a very light, clean feel, much like the

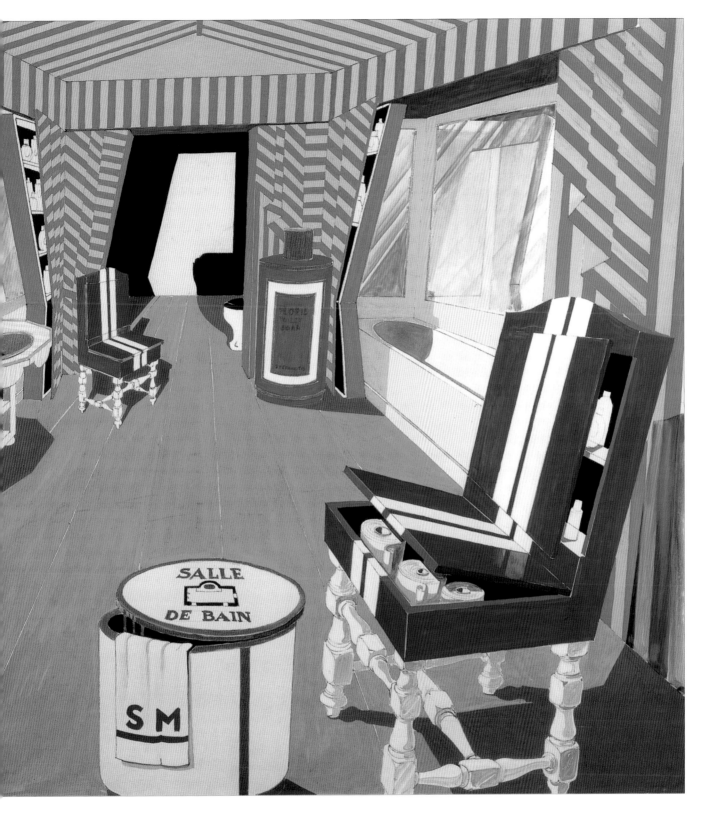

white hygienic-looking bathrooms of the first decades of the century.

Thomas Sandell, of Sandell Sandberg, is one of the foremost furniture designers and architects in the Swedish modern style of the 1990s. He has worked extensively for the Swedish-based interior decoration retailer, Ikea, and his ideas have been spread extensively, influencing the decoration and furnishing of many homes in Britain, where Ikea has been particularly successful in exporting the Swedish modern look.

Bedrooms

The function and furnishings of the rooms we sleep in changed remarkably little during the 20th century. The bedroom became a more private room than it had been historically, and it is perhaps because it was the room least seen by visitors that it had less money spent on its decoration and furnishings. One of the marked changes in the first decades of the century was the removal of the washstand, which had been included in matching bedroom suites of furniture. The transporting of hot water up to bedrooms was a complicated business, and one commentator at the turn of the century suggested that this could be reduced by fitting taps in the bedroom. Although basins in bedrooms existed from the 1930s, this was not usually in place of a bathroom. With the increase in bathrooms during the first decade, the washstand became obsolete, although they could still be found in some homes as late as the 1940s and 1950s. The revival of interest in period furniture during the 1980s included washstands, however (particularly those with marble tops), and they became interesting pieces of decorative furniture to spread about the house.

But beds remained the most important feature, and by the beginning of the century they tended to take the basic board form – four short legs, a headboard and sometimes a footboard – still in use today. At the beginning of the century and at points throughout, the four-poster was still desirable as a luxurious period revival piece, and the canopied model also survived, again in wealthy homes. One of the most common bed types, however, was the iron bedstead. With the reduction of dressing rooms, bedrooms in this century also contained furniture for storing clothes and for the toilette. Tall, box-like wardrobes for hanging clothes and shorter chests-of-drawers for small and folded garments had fairly standard, practical forms throughout the century. Some wardrobes were fitted with shelves, avoiding the need for a separate chest. With the Modernist style of the 1930s came fitted wardrobes with clean neat lines; they regained popularity in the 1970s so that freestanding pieces were not the only option. Also during the 1970s, influenced by American models, there was an emphasis on the larger, king-size bed as a feature in the room. This also took in a fashion for low-lying beds, such as Japanese futons and waterbeds. Unfortunately the standard bedroom size in British houses, being smaller than American standard rooms, could not easily accommodate the luxury of an above-average sized bed, and as building space became more and more precious, British bedrooms and beds tended to remain smaller.

Lack of space also accounts for the lack of walk-in closets, a typical feature of American bedrooms.

In the early 1980s continental quilts, or duvets, caused a radical change in bedding arrangements as they began to replace sheets, blankets and eider-downs. Duvets, with patterned, curtain-matching covers, became part of a general revival of interest in the bedroom, which had first begun in living rooms in the 1950s. By the 1970s co-ordinated furnishing patterns were popular throughout the home, used not only in curtains and wallpapers, but also for bed-linen, towelling, lampshades and waste-paper bins. In children's bedrooms at this time, themed decorations were often taken from characters in story books or from television programmes and the cinema. This was an important era for the consolidation of media-spread culture, where the children's market was successfully targeted by advertisers and whole ranges of diverse products with a single unifying theme were produced. Children's bed-rooms received much attention as they often had to incorporate the activities from disappearing nurseries into an ever-decreasing space, and bunk beds and platformed beds with desks underneath developed.

The heritage revival in the 1980s saw the return to fashion of freestanding bedroom furniture, usually in the Scandinavian pine-wood style, and even the blackened cast-iron bedstead became desirable in the increasingly stark, Shaker-like sleeping spaces of the late 1980s and 1990s. The experience of sleeping 'in the clouds' was experimented with in loft-living of the 1990s, often resulting in minimalist beds being placed on open platforms or mezza-nine floors with little other furniture.

One important development in the 20th-century sleeping space was the bed-sit. Based on the late 19th-century urban bachelor room, it was devel-oped extensively by Modernist architects and designers in the late 1920s and 1930s for single professionals. Seen to be a practical solution to modern urban living, and interrupted by the war, the idea was taken up again in the early 1950s. A respectable and convenient living, sleeping and cooking room, it catered for the growing number of single professionals. By the 1970s it was also used extensively by students, and versions including built-in desk arrangements were adapted into new student housing.

The general interest in sleeping quarters grew after the 1950s. The increas-ingly affluent late 1950s and early 1960s resulted in more leisure time, which led to more attention being paid to bedroom furnishings and decoration in

an attempt to make a more pleasurable environment. As private havens in the midst of the other, activity-based spaces, they increasingly became spaces for personal expression created through decoration and design. While the forms and types of furniture tended to remain the same, the range of available styles thought suitable for a bedchamber expanded. Whether they were exercises in stark and pale Shaker purity, country-style pine, extravagant Neo-Baroque with gilding and dark velvets, the exotic and opulent with rich-coloured Eastern silks, or a minimalist, white-walled bed platform, sleeping areas had become much more valued and interesting spaces in the home at the end of the century.

71 (opposite)

The 'St Ives' suite of bedroom furniture, 1901

Heal & Son, London
Bookplate
V&A: AAD/1978/2/275

This illustration, showing an arrangement for bedroom furniture advertised in Heal's brochure *Bedsteads, Bedding & Bedroom Furniture*, and available at their shop in Tottenham Court Road, London, gives an indication of both the type of furniture that was used at this time and the Arts and Crafts style. The 'St Ives' suite consisted of a wardrobe with a plate-glass door, a dressing table with a mirror, a marble-topped washstand with a tile back and brass towel rails, and two chairs. The furniture was available in solid oak or ash, stained green or brown. Apart from the carved heart motifs and the wrought-iron hinges and handles,

both common in Arts and Crafts decoration, the furniture is devoid of decoration. Combined with the bare floorboards, naked except for a small turkey carpet for barefooted washers to stand upon, and the beam-effect around the bay window, the overall effect is rather stark. The bedstead was not part of the suite but was also available at Heal & Son. This type of plain and bare style was not particularly common in middle-class homes, which would have been decorated with more fabrics and floor-coverings. The name of the suite probably refers to the Cornish artistic colony, from which it derives the rustic, spartan look.

72

Design for a Regency bed, *c.*1908

Mewès & Davies, Paris (worked in the first decade of the 20th century)
Pencil and watercolour
V&A: E.866.45–1975

This Paris-based company had a London office, and at the turn of the 20th century was designing furniture very much in the grand historical styles of the French court. This design for a bed in the style of the 1720s is from an album of designs for all types of bedroom furniture, including matching wardrobes, bed-side tables and chaises longues. The elaborate gilded bed-head and footboard, with hoofed feet and legs derived from

chair or chest-of-drawer legs, was typical of their work. Other looks that appealed to middle-class taste at this time included less exuberant, though equally grand forms such as Neo-classical or Empire styles. Beds, wardrobes and other furniture were veneered, gilded and adorned with ormolu mounts to suit the Parisian apartments and hotels.

The designs in this album are executed in a pretty, light manner making them all the more attractive to prospective customers.

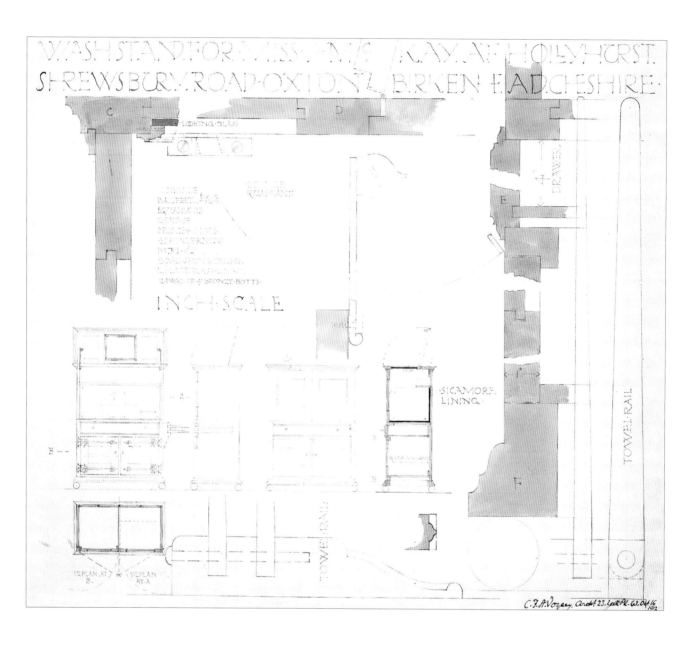

Design for a washstand for Miss D. McKay, 1912

C.F.A. Voysey (1857–1941)
Pencil and watercolour
V&A: E.285–1913

This constructional design drawing is typical of Voysey's architecturally trained draughtsmanship. First he would put the commissioner's name and address at the top of the large sheet of paper in a big stylised typeface. He then filled the paper with a range of precisely executed elevations, plans and details in different scales, all clearly drawn and labelled and finished off with his signature and date at the bottom.

One of the main Arts and Crafts proponents working in this style at the beginning of the 20th century, Voysey liked to keep the decoration on his works to a minimum. This piece of furniture has bronze hinges and fittings as the only addition to the oak and sycamore wood construction, very like the furniture in the 'St Ives' suite shown in plate 71, which was strongly influenced by his work. This washstand is a rather clever design –

when not in use it looked like a closed cupboard, but opened up (including the top which contained a mirror) to reveal the bowl and jug, with a towel rail on the side. Most of Voysey's designs were for individual pieces rather than complete architectural furnishing schemes, and this washstand is very typical in that it is a small commission for a particular piece of furniture for domestic use. In 1902 Voysey made some furniture designs for a Mrs van Gruisen, who lived a few streets away from Miss McKay in Oxton, Cheshire. It is likely that they knew each other, and that Miss McKay liked what she had seen in her friend's house and ordered the washstand for her own home.

Design for a bedroom, late 1920s

Berta Sander (1900–90)
Pencil on tracing paper
V&A: E.1393–1986

This simple, modern bedroom has an orderly, though not too austere approach to furnishing and decoration (like the kitchen/diner by Berta Sander in plate 33). Sander trained at the Wiener Werkstätte during the mid-1920s and was heavily influenced by the International Modernism that was prevalent in Vienna and Germany at this time. She returned to Germany to set up practice designing textiles

and wallpapers as well as furniture and room schemes. Her interest in surface pattern is seen here in the light floral repeat pattern on the matching lampshades and bedcover, which stand out against the plain walls. The stark, straight lines of the wardrobe and dressing table are balanced by the rounded forms of the lamps and sleigh bed. Her practical, space-saving techniques can be seen in the shelves which are neatly fitted into the end on the wardrobe, so avoiding the clutter of extra furniture. Sander emigrated to Britain in 1936 but, denied a work permit, was unable to continue her career.

Design for a bedroom, 1925–30

William Henry Haynes & Co.
Ink and watercolour on board
V&A: E.4–1977

This perspective design for a bedroom in the Regency style was probably influenced by Parisian tastes – the source for most fashionable taste in Britain in the first three decades of the century. Classical styles were traditionally more popular in Britain than those of the more opulent and grand French courts as seen in the Mewès & Davies bed design in plate 72. Regency elements here are the spindly, elegant forms in the furniture, and the pale blues, pinks and greens of the colour scheme, which give an overall light feel to the room. The white colouring, however, is a 20th-century variation. There are references to Grecian forms in the dressing table legs, the shape of the bed (which is like a day bed), and right down to the bolster with tassel and the drop-crystal light-fittings.

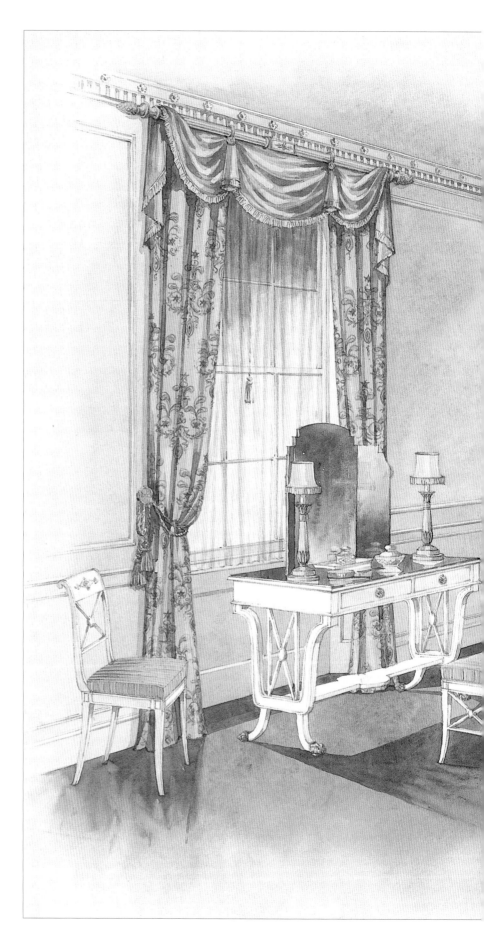

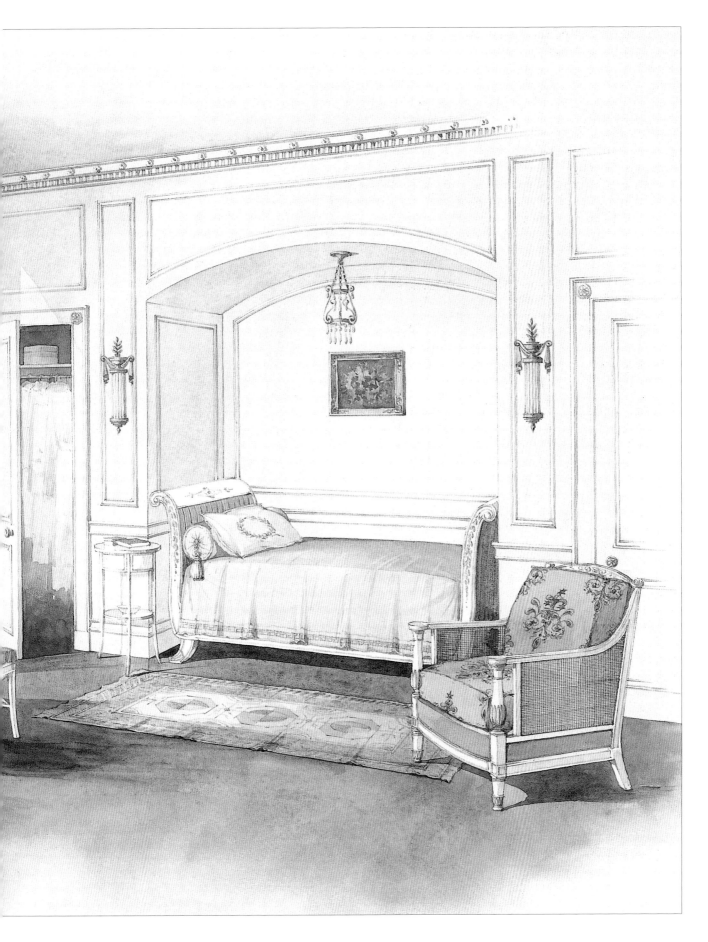

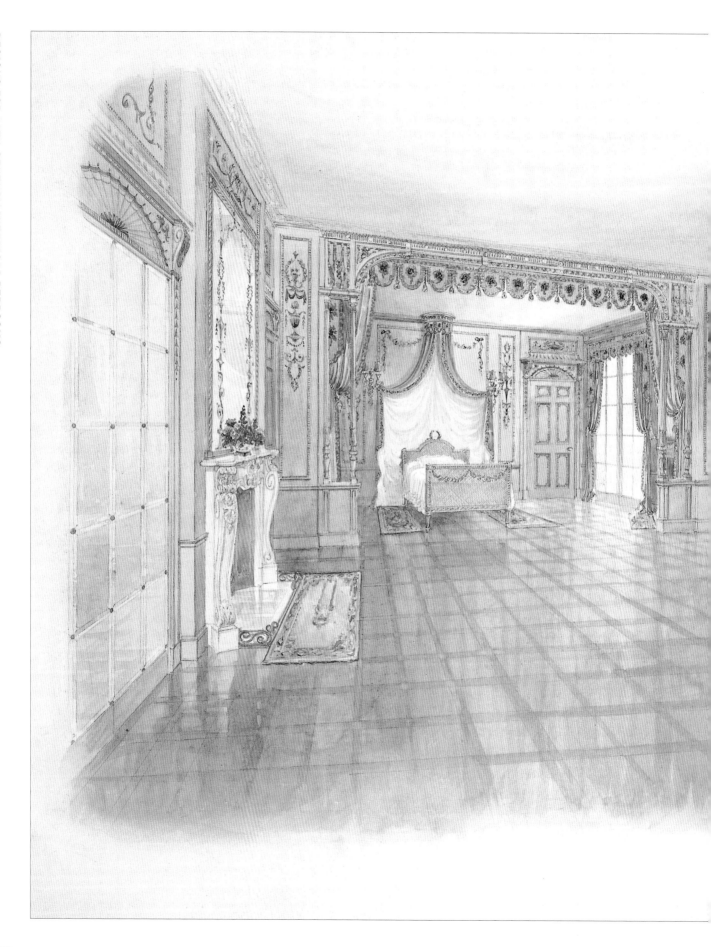

Design for a bedroom, 1930s

B. Carpenter (active 1930s)
Pencil and watercolour and bodycolour
V&A: E.303–1998

The low viewpoint of this design gives a dramatic perspective to the room. The bedroom looks like a Hollywood film set, which were extremely influential to the enormous movie-going crowds of the period (see also plate 58). The great expanse of polished parquet wood floor, the marble fireplace and the plush hangings around the bed suggest an opulent, carefree and glamorous lifestyle. The soft-focus edges of the drawing bring a dream-like quality to the bedroom. The panelling and colourful gesso decoration and the whole scheme is very much on a grand scale in the Neo-classical style of Louis XVI. The room in the foreground incorporates the wardrobe on the left with a full-length mirror on the central door, while the bed is positioned in an alcove after the 18th-century fashion. Stripped of furniture, the bedroom has a strong sense of spaciousness, resembling the look of a ballroom. It is unlikely that there were many who could have afforded a bedroom like this in a private house – it is possible it could have been for an hotel.

Design for a bedroom, 1930s

Elfrida Mostyn (d.1977)
Pencil and watercolour
V&A: E.692–1981

Probably for a flat, this bedroom design, has a much more practical feel to it than B. Carpenter's idea for a bedroom in plate 76, and looks more like a typical middle-class bedroom of the 1930s and 1940s. The traditional furniture combines mid-Georgian features with the clean lines, motifs and rich colouring of Art Deco. The modern plainness of the period-style panelled walls contrast with the startling strong blue of the carpet, recalling Far Eastern ceramics, emphasised by the decorative vase on the window sill. The rest of the decoration also has an oriental feel, with the rug (unusually laid onto a carpet) and the shiny silk coverlet. Shiny surfaces were an important feature of 1930's interiors, and are picked out here in the pouffe, cushion and furniture. The modified historical revival 'Chippendale' chairback and the cabriole legs of the wardrobe are contrasted with the tiered Art Deco profile of the bed-head.

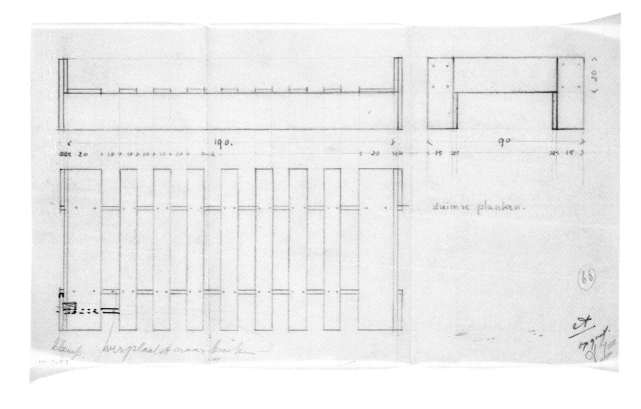

Design for a 'Crate' bed, 1934

Gerrit Thomas Rietveld (1888–1964)
Pencil, pen and ink
V&A: E.1763–1991

This bed design was for the 'Krat' (Crate) range of furniture sold by the Amsterdam store of Metz & Co. from about 1935. The range, about as simple as wooden furniture could get, was a response to the worldwide economic slump of the 1930s. Rietveld intended the crudeness of the materials and form to be a design statement. Made from low-grade, single-thickness timber normally used for making crates, the planks were sold as a flatpack for home assembly, much like a base for a futon today. Rietveld's drawings indicate the construction of the bed base, the dimensions and where the screws should go. He was very specific about the positioning of the screws, and if

customers wished to paint the furniture (he preferred them not to), as seen in the chair below, he wanted the screws to be fitted afterwards so that they showed as decorative elements. This particular design doesn't appear in any of the Metz & Co. catalogues and so might not have been produced.

Rietveld is better known for his revolutionary, abstract forms in furniture design. The 'Crate' range,

however, for all its simplistic and plain design, is not very different in essence to more famous pieces such as the 'Red/Blue' chair of 1918, which comprises a series of geometric, standardised wooden uprights and horizontals. It did not receive its distinctive colouring until a year after it was originally made, and even the angle of the seat is very similar to the 'Crate' chair.

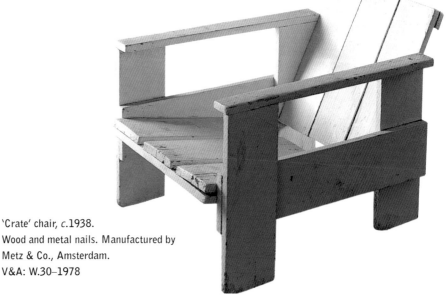

'Crate' chair, c.1938.
Wood and metal nails. Manufactured by Metz & Co., Amsterdam.
V&A: W.30–1978

Design for light-fitting for a bedroom, 1945

George Wooller (worked second quarter of the 20th century)
Pencil and gouache
V&A: E.1249–1984

The bedroom, with a 1945 copyright, was very much a throw-back to 1930's Art Deco styling. The ceiling lamp shown here resembles a Chinese lantern complete with dangling tassel, which was a popular motif in the late 1920s and early 1930s. The plush bedroom setting was invented by Wooller, and is similar to those he designed for ocean-going liners during this time. With lots of machine-aesthetic curves, though probably actually hand-made, the emphasis on shiny, shimmering surfaces is like the earlier Elfrida Mostyn bedroom (plate 77), and has an air of luxury about it. The blend of cream and green, together with the rich honey tone of the wood, is reminiscent of Art Deco interiors, and it seems Wooller was attempting, during the austere war years, to recapture a previous period of prosperity and extravagance in design. It would have contrasted dramatically with the austere, plain Utility bedroom furniture which was all that was available in Britain between 1941 and 1953.

The plush bedroom setting ... is similar to those he designed for ocean-going liners during this time.

Components of 'Utility' bedroom furniture, 1948

Anonymous illustrator for
the Board of Trade catalogue,
Specification for Utility Furniture
V&A: E.640–1999

Like other rooms in the house, as highlighted in the Living Rooms chapter, Utility bedroom furniture had to be economical with materials. This resulted in little or no embellishments or carved features, and construction methods (as seen in this component catalogue illustration) intended for manufacturers were kept simple. Wartime bedrooms were often more sparse than usual, and for practical and hygienic reasons usually had linoleum as a floor covering, particularly under the bed.

81 (right)

Designer's impression of a bed-sitting room furnished with 'G-Plan', 1954–55

Leslie Dandy (b.1923) for E. Gomme &
Sons, High Wycombe
Pencil, watercolour and bodycolour
V&A: E.334–1978

This is an earlier version of the 'G-Plan' furniture range seen in the sitting room suite in plate 18. The restrained, lightweight forms and emphasis on storage were particularly suited to small rooms such as bed-sits, where space was at a minimum. This bed-sit is well balanced, both in arrangement and the use of colours – the tones of the furnishings are subtle, but with contemporary patterns – and the whole effect is discreetly modern. 'G-Plan' furniture, which was first brought onto the market in 1953,

was a conscious reaction against the exaggerated forms and embellishments of traditional period styles which were being produced at this time. Influenced by the slender forms of Scandinavian design, it was the first major commercial attempt in Britain to mass-produce well-designed furniture that was modern in concept. It provided a new approach to home furnishing, with interchangeable pieces of matching furniture making it possible (pocket allowing) to build up a unified interior, as also seen in the living room furniture suite shown earlier in the book. During the 1950s, one-room living for single people, usually professionals (many who had recently left the forces), was on the increase. It catered for a post-war group which was increasingly mobile, as well as single people who didn't wish to be committed to home ownership.

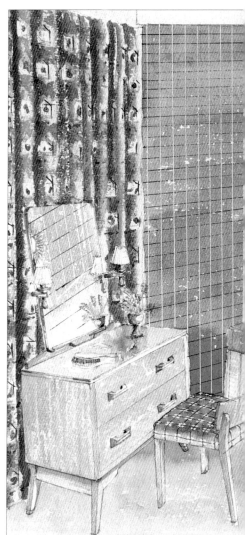

Design for 'Madrigal' bed-head unit, 1959–60

Sylvia (b.1924) and John Reid (b.1925) for the Stag Cabinet Company Ltd.

Pencil

V&A: E.111–1978

This sketch for a headboard unit for the 'Madrigal' range of bedroom furniture shows the middle-market taste for period revival furniture of the early 1960s. The American colonial-style look with dark turned poles in contrast with the very up-to-the-minute brown crushed velvet coverlet, as seen below in the later but very similar 'Minstrel' range, was very popular. Also available in a four-poster bed version, it had historical overtones, but was not as bulky as traditional period furniture, which was important in the decreasing size of bedrooms. Integrated bedside tables for extra ease and comfort were not new, and had been a feature of some 1930's beds. But the use of a period style in a piece of modern furniture was typical of this period. The Stag Cabinet Company Ltd. were, like E. Gomme & Sons who produced 'G-Plan', based in the traditional furniture manufacturing centre just north of London, and were influential in British furniture design from the 1940s.

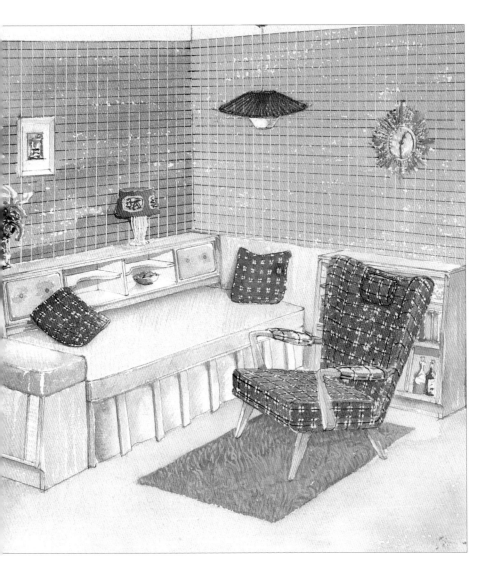

Above. Our Continental headboard takes an ordinary bed and transforms it into a piece of Minstrel. A finishing touch to the Minstrel bedroom.

Marketing brochure showing 'Minstrel' range of bedroom furniture. 1963.
V&A: E.111A–1978

Design for a bedroom interior, *c.*1973

Allan Day (b.1939) for Zeev Aram & Associates

Pencil, crayon, watercolour and collage
V&A: E.820–1979

Highly influenced by American models, this spacious bedroom with large, low-lying bed was the height of sophisticated luxury in the mid-1970s. The extensive use of warm chocolate-brown combined with passionate-red details was particularly common in bedrooms at this time.

The clean lines of the floor-to-ceiling storage and shiny surfaces contrast with the fluffy bed cover. There is also the use of floor-to-ceiling mirroring on the far wall to accentuate the impression of space. Recessed ceiling lighting and metallic lamps fixed to the walls on extendable arms were seen as part of the hi-tech look, although particularly in the area of lighting they were based on Modernist originals from the late 1920s and 1930s. However, the compulsory addition of the television at the end of the bed makes this a quintessential 1970's bedroom.

Recessed ceiling lighting and metallic lamps fixed to the walls … were seen as part of the hi-tech look.

Design for a bed-sit, c.1973

Allan Day (b.1939) for Zeev Aram & Associates
Pencil, ink, crayon and watercolour
V&A: E.822A–1979

This early 1970's bed-sit has a very different atmosphere, though similar forms, from the previous Allan Day bedroom (opposite). It has a distinctly younger appeal with its fresher, brighter look. The white-on-white fitted furniture and walls give it a very plain look, while the light colour of the room gives the long narrow shape an air of space, although it does have something of a cell about it. The starkness and sharp straight lines are alleviated by the warm-brown sofa-bed which, with its thick rounded arms and back, looks very cosy. The white fitted cupboards are part of the mass-market acceptance of Modernism in the home, and together with the steel-framed cantilevered chair the whole look is a popular 1970's homage to Modernism.

'Silk passage' textile design for bedlinen and towels, 1981

Susan Collier (b.1939) and Sarah Campell (b.1945) for Martex Ltd.
Pencil and bodycolour on two sheets joined together
V&A: E.261&A–1984

The colours and busy, geometric, slightly abstract pattern of this furnishing fabric design is typical of the 1980's look. Based on an ikat design, it shows the acceptance and appropriation of ethnic designs into mainstream home decoration in Britain. Ethnic products had been popularly used as decorations since the mid-1960s, and some motifs were used to decorate ceramic wares, but they tended to be taken up by the so-called 'hippie' sub-culture. By the 1980s it was a respectable style for fabrics and wallpapers in bedrooms and living rooms.

... the acceptance of ethnic designs into mainstream home decoration.

Rdroom for Miss Fay Dunaway

D. Roos
1985.

'Bedroom for Miss Faye Dunaway', 1985

David Roos (b.1950)
Pen and ink and watercolour
V&A: E.302–1986

This highly theatrical version of the late 1980's baroque revival is particularly appropriate for its actress patron, Faye Dunaway. Part of the New Romantic rediscovery of 18th- and early 19th-century styles, it is also highly expressive of the user's character. It is not simply another historical revival but an ironical Postmodernist take on historicism. For example, the drapes over the bed bear no functional relation to their historic precedents, and the rings are an unusual, unhistorical idea. The pedimented form of the bed-head

was a key Postmodern motif. The overall result is of a romantic and feminine bedroom with more than a touch of the dramatic given by the layered and juxtaposed window drapes, typical of Roos's work. The tall iron-work candlesticks on spindly bedside tables brought a modern feel to the bedroom, which was executed in Faye Dunaway's London house.

Index

Page entries in *italics* refer to illustrations

Acknowledgements

With special thanks to Susan Lambert, Chief Curator of the V&A's Department of Prints, Drawings and Paintings, and Michael Snodin, Head of Designs for his support, suggestions and proof reading, to Charles Newton for his dedicated support from the beginning, and to my colleagues Shaun Cole and Mor Thunder for their forbearance and ferrying of objects for photography. Also to innumerable colleagues across the museum, in particular Stella Harpley of the Education Department; in the Photographic Studio, Ken Jackson, Graham Brandon and colleagues; and Mary Butler and Miranda Harrison of V&A Publications.

I would also like to thank Denise Hajströerm for her kind help in Sweden, and Thomas Sandell and Pye Aurell of Sandell Sanberg AE, and Duncan Chapman of Circus Architects, for their generosity and swift co-operation. And lastly, I am grateful for the support and tolerance of all my friends, and particularly the encouragement and helpful suggestions of Benyouness Msaad, Donald Gibbons, Dr Ruth Taylor and Dr Nicholas Moran.